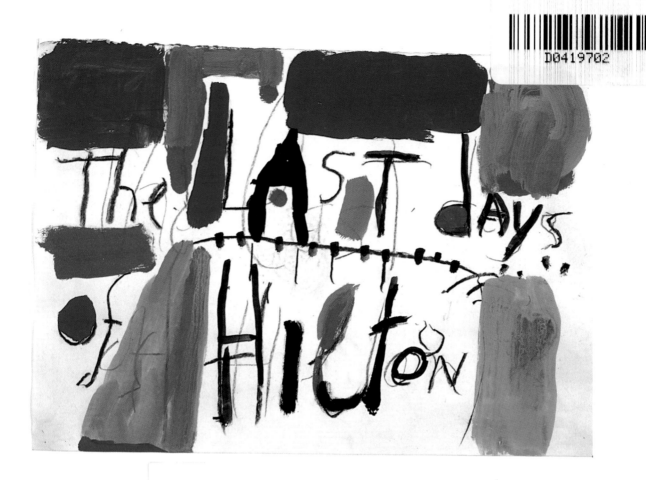

The Last Days of Hilton

LEWIS

Sansom & Company

First published in 1996 by
Sansom & Company,
an imprint of Redcliffe Press Ltd.,
22 Canynge Square, Clifton, Bristol BS8 3LA

Text © Adrian Lewis
Reproductions of the artist's work
© Rose Hilton

The front cover illustration was kindly
provided by The Hayward Gallery, London.

ISBN 1 900178 05 2

British Library Cataloguing in Publication Data
A catalogue record for this book is available
from the British Library.

Design: Steve Leary, Bristol.
Printed by Longdunn Press, Bristol.

C O N T E N T S

Cover illustrations: front - 1974, gouache and charcoal on paper 13½" x 16¼"; rear - 1974, gouache on paper 17" x 13½". Title page: gouache and charcoal on paper, 15⅞" x 22".

My interest in the work of Roger Hilton goes back to his Serpentine Gallery retrospective in 1974 and it is twenty-one years since I first visited the Botallack Moor cottage where his late gouaches were produced. Since then my interest in the late gouaches has increased and this book has been written to suggest aspects of their fuller significance to others for whom they are still only an interesting postscript to his oils of the late 1950s and early 1960s. The extent to which interest in his late gouaches was limited struck me forcefully during conversations connected with the 1993 Hayward Gallery retrospective.

A few further words about the presentation of this book seem called for. The decision to expunge titles which have accumulated for artworld convenience was mine. Owners' names have not been appended to basic data about pictures. Again this decision to extract the work from ownership within the ideality of the book is deliberate, capturing one impulse in Hilton's artistic behaviour, though this does not mean that the contradictory impulse to have his work collected was not also important.

As a practising artist, I have been aware of the distinction between the pattern of art production and its intrinsic (mis)representation in texts where costs restrict the number of works illustrated and the range of collections tapped. We have tried to maximise the number of reproductions and to give priority for colour illustration to work which has not been widely illustrated. That is the only reason for choosing not to reproduce again in colour (except for the cover illustrations) some images already seen in colour in the 1993 Hayward Gallery catalogue. I have also assumed — disagreeing again with opinions voiced in the art and publishing worlds — that it is slightly absurd to consider that there is already a 'canon' of basic Hilton images which require reproducing in any definitive text. I am assuming that the question of quality will have something to do with how we experience and understand this work and that some openness of enquiry is still required in thinking about why we are interested in it in the first place.

This book could not have been produced without the support of Rose Hilton, who granted copyright permission for the reproductions, the enthusiasm of the publisher John Sansom, or my parents' support of the project against financial loss. Many thanks to them and to the collectors who have seen their images transported to this 'collection without walls' (and to Reg Watkiss for consent to use one of his documentary photographs of Hilton). My thanks to Sarah Tooley at Waddingtons, and for photographs to David Cottington, Tony Hepworth, Sydney Alstadt, Sotheby's and the Hayward Gallery. Without the constant encouragement and support of my wife Val Lewis, the larger project of which this publication is but a preliminary part might not have been brought to some kind of completion. However, this text finally emerged because I was kept continually intrigued in the process of writing about Hilton's late gouaches, because I found myself constantly stimulated in the problematic job of talking about this challenging work and confronted by it to find adequate explanatory frames.

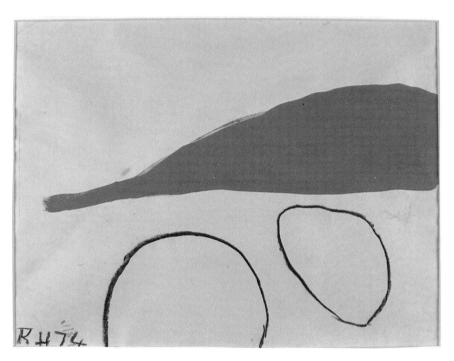

Ill. 1 1974, gouache and charcoal on paper, 15⅞" x 21½".

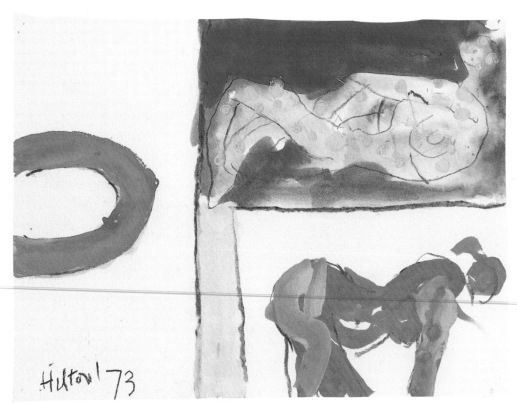

Ill. 2 1973, gouache and charcoal on card, 11⅛" x 15⅛".(photo: Tony Hepworth Gallery)

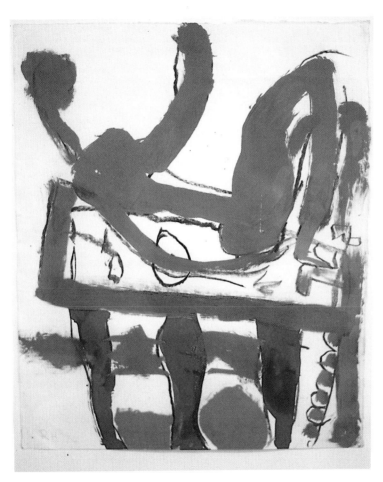

Ill. 3 1974, gouache and charcoal on paper, 20" x 16¾".

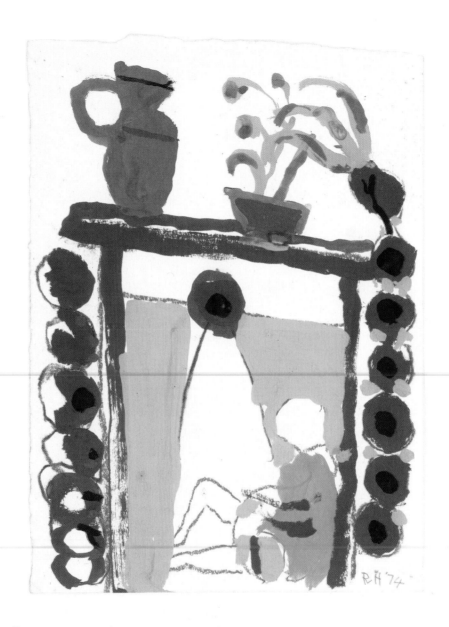

Ill. 4 1974, gouache and charcoal on
paper, 16" x 11¾".(photo: Sotheby's)

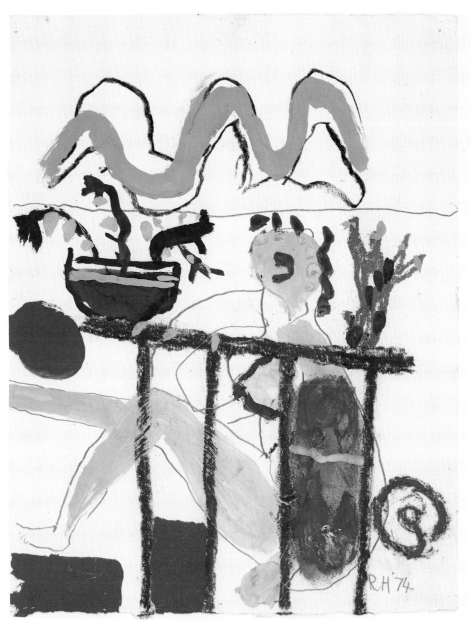

Ill. 5 1974, gouache, charcoal and pastel on paper, 14½" x 11¾".

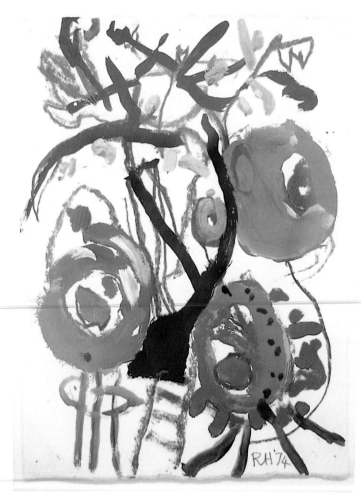

Ill. 6 1974, gouache and pastel on paper, 13³/₈ " x 10".

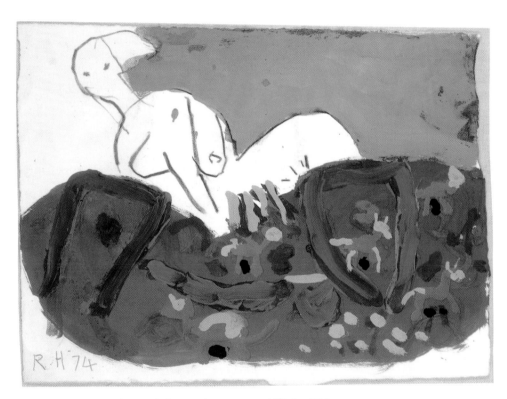

Ill. 7 1974, gouache and charcoal on paper, 14½" x 20".

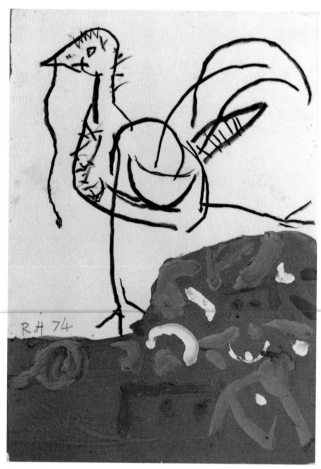

Ill. 8 1974, gouache and charcoal on paper, 22" x 15¼".

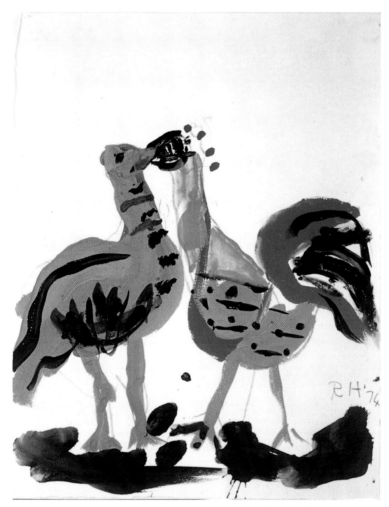

Ill. 9 1974, gouache and pastel on paper, 16³/₄" x 13¹/₄".

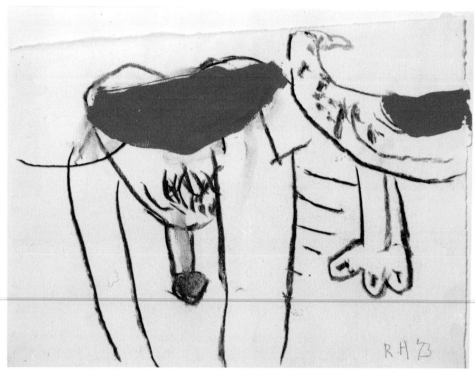

Ill. 10 1973, charcoal and gouache on paper, 10½"-11⅛" x 14⅞".

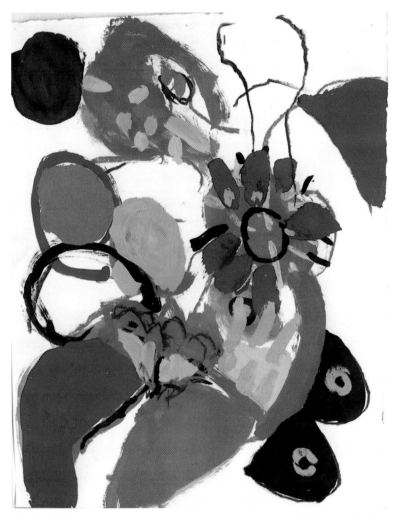

Ill. 11 1975, gouache, pastel and charcoal on paper, 19³/₄ " x 15¹/₂ "-
15³/₄ ".

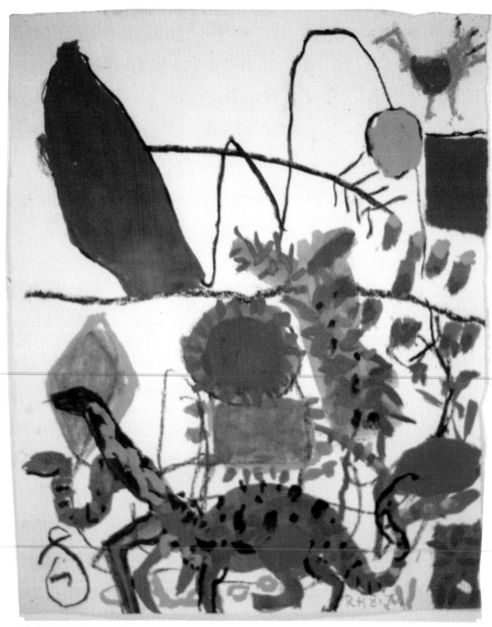

Ill. 12 1974, gouache, pastel and charcoal on paper, 16¾" x 13½".

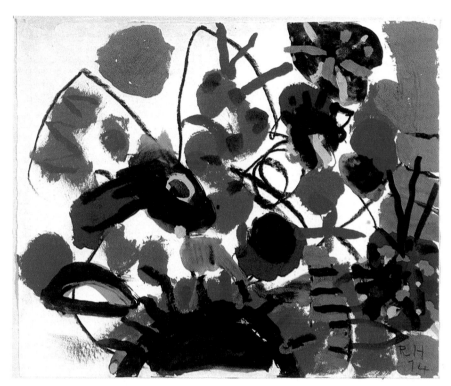

Ill. 13 1974, gouache and charcoal on paper, 14" x 17¼".

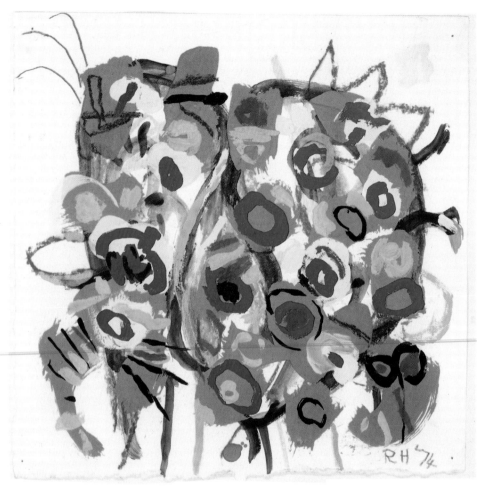

Ill. 14 1974, gouache and charcoal on paper, 13¼" x 13½".(photo: Sotheby's)

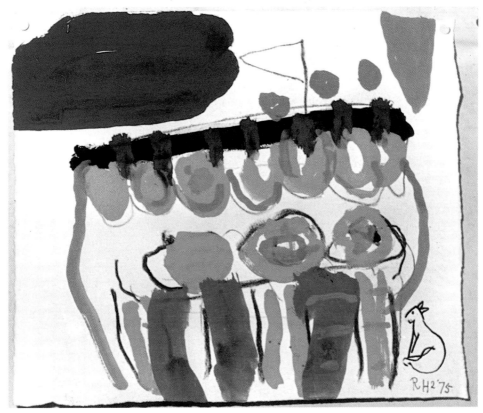

Ill. 15 Feb. 1975, gouache and charcoal on paper, 14" x 16½".

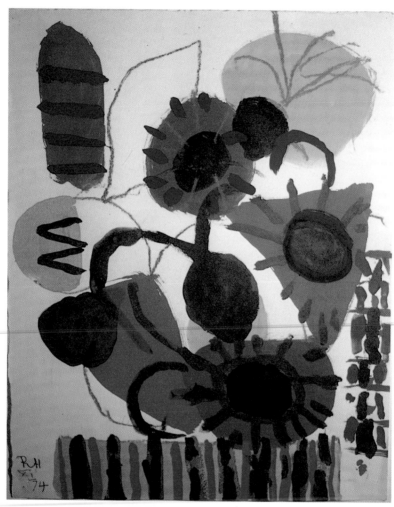

Ill. 16 Nov. 1974, gouache and pastel on paper, 18¼″ x 14¾″.

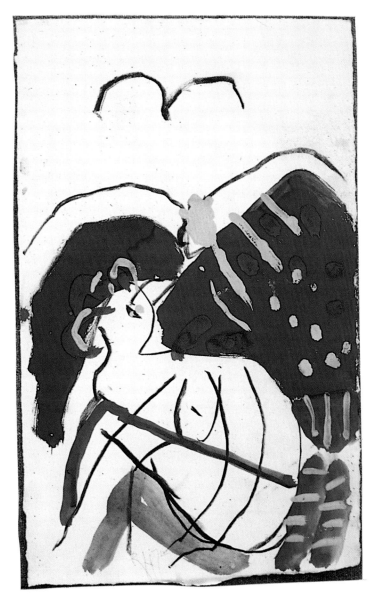

Ill. 17 1974, gouache and charcoal on paper, 22½" x 13½".

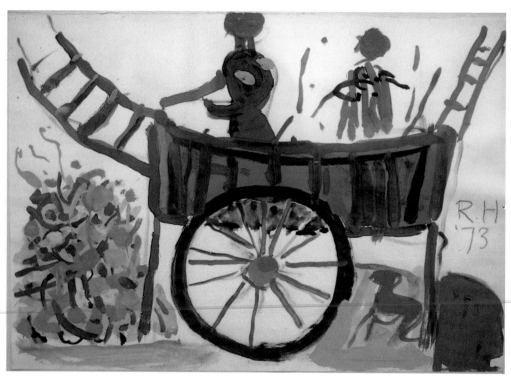

Ill. 18 1973, gouache on paper, 15¼" x 21⅞".

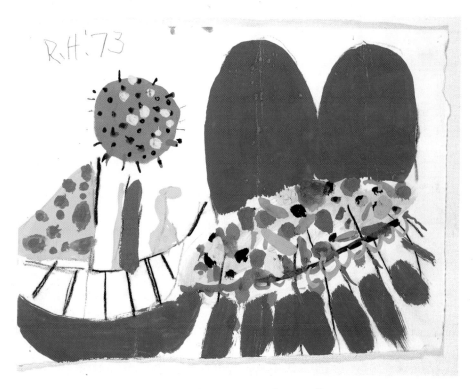

Ill. 19 1973, gouache and charcoal on paper, 11½ " x 14¾ ".

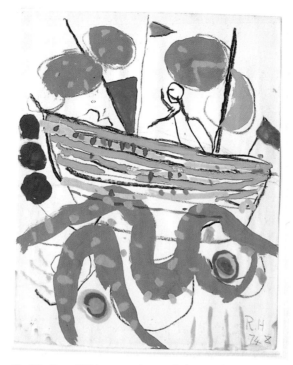

Ill. 20 Oct, 1974, gouache and charcoal on paper, 18½" x 15".

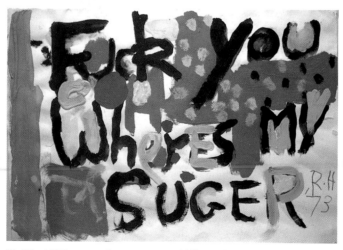

Ill. 21 1973, gouache on paper, 15¼" x 22".

THE LAST DAYS OF HILTON

On February 23 1975, Roger Hilton died following a stroke, exactly a month short of his 64th birthday. He had established his artworld position in the late 1950s and early 1960s with painterly abstract work, based during these years in London, though making frequent trips to Cornwall. In 1961 he began a second family with his new partner Rose Phipps, and they married shortly before the birth of their second son in 1965. In that same year, the family moved from London to the cottage at Botallack Moor near St. Just (fig.1) in which he died a decade later. His physical decline is usually attributed to peripheral neuritis, but this is a well-recognised consequence of alcoholism.

From October 1972 until his death, Hilton was unable to use the first-floor studio in his Botallack cottage and was confined to a ground floor bed. It was at Christmas 1972 that he began playing with poster paints given as a present by his sister-in-law to one of his sons. Unable to paint in oils in his upstairs studio, Hilton then seized on water-soluble body colour and various drawing media to enable him to continue working from his sick-bed. This study focuses on the rich complexity and cultural significance of these 1973-5 gouaches.

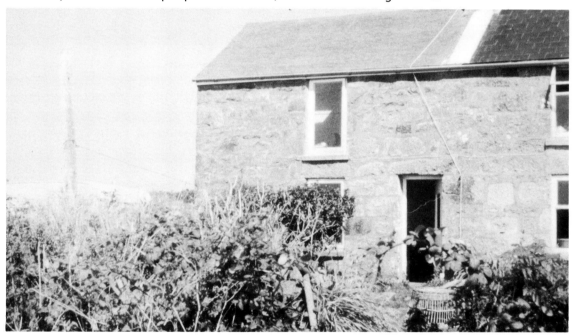

Fig.1 Hilton's ground-floor room and first-floor studio in the Bottallack Moor cottage. [Adrian Lewis]

View from the Sick-bed

Let us begin with an image of the sick-bed. A photograph by Reg Watkiss (fig.2) shows Hilton with tablets, cigarettes, books and music within easy reach, leaning on his left elbow. Indeed, having been left-handed, he had taught himself to work with both hands in order to ease the effect of leaning constantly on one elbow. A 1973 charcoal drawing (now in the collection of Sonya Fawcett) lies to the left of his bed. It is based on his cat Columbus, whom he found both enchanting and infuriating (since, among other things, it drank his paint-water). Other photographs taken by Jorge Lewinski show that he sometimes worked seated on the bed but that often he worked lying down.[1]

Such an image of making art in the face of ill-health and impending death brings to mind the example of an artist like Matisse, changing from oil-painting to paper cut-out partly because he was able to create such work more easily from a wheelchair following an operation in 1941. Indeed Hilton treasured his copy of the reduced format 1957 Piper version of Matisse's *Jazz*. David Piper recalled that Hilton 'swore by Matisse' as early as 1946-7 and Terry Frost says that Hilton actually translated Matisse's writings for him. In his writing Matisse made much of the notion of aesthetic rejuvenation, involving a rediscovery of energy by returning to the basic means of art. In February 1954, the British magazine *Art News and Review* had published Matisse's essay 'Looking at Life with the Eyes of a Child' in which a 'return' to child-like vision is associated with a process of forgetting inherited schemata. (I shall have occasion to look at the problematics of this position later)

Hilton's circumstances are less grand, much more elementary than those found in photographic images of the invalid Matisse at work. The defiant grin is different too from Matisse's public image of serene withdrawal. Hilton's willingness to handle potentially embarrassing feelings (as in the sexual arena, where arousal was accompanied by impotence, fig.6 and ill.10) is quite different from the Kantian disinterest which Matisse organized aesthetically when it came to images of the opposite sex.

One death-bed image by Hilton is particularly revealing (fig.3). It is a reprise of Delacroix's *The Death of Sardanapalus* (fig.4, 1827-8, Louvre), but Delacroix's interest in the theme of aloof unconcern at the destruction of worldly power and wealth is not the same as Hilton's. Sardanapalus is undressed and sexually tweaked, surrounded only by female figures whose extended arms constitute (along with the circular forms) projections of frustrated sexual feelings. Hilton has changed the right-hand stabbing male into a female figure. Fertile green is the couch's colouring, whereas Delacroix's work is threaded through with touches of red sug-

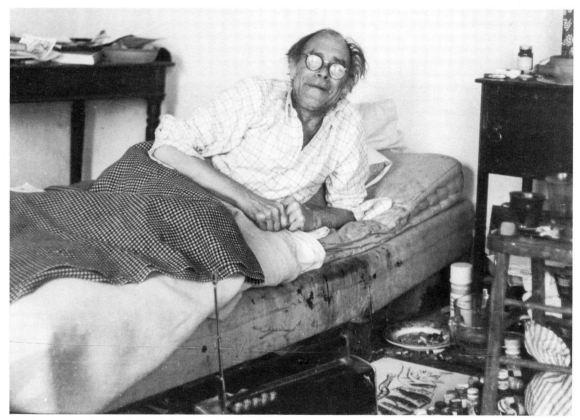

Fig.2 Roger Hilton,1973. [photo: Reg Watkiss]

gestive of fire and blood. Delacroix's pictorial sadism is absent and instead rolled bedding possibly suggests a yin-yan symbol of harmony of opposites. Hilton's more simple and planar layout with attendant women who could be mourners as much as playmates recalls scenes of mourning on Greek vases as well as those antique sarcophagal scenes which Delacroix may have been transposing into a more dynamic and spatially disjunctive idiom. Hilton is focused on arousal on the sick-bed and its ultimate hopelessness. One late Hilton note includes a drawing which surrounds a recumbent male with sprouting vegetation, his erection participating in this dance of organic life (fig.6). His eroticism is projective ('the fun is over') and perhaps accompanied also by certain pathos.

Sardanapalus after Delacroix is also interesting in connecting Hilton with models of

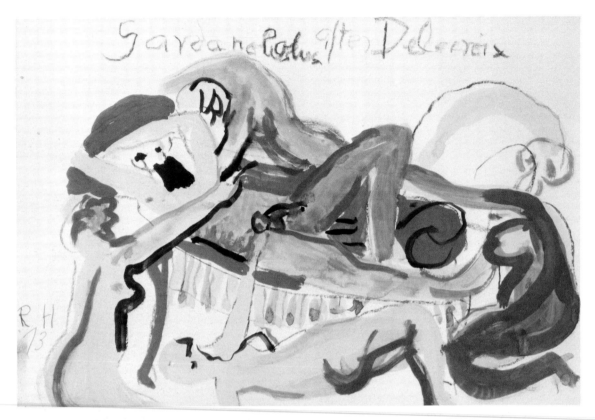

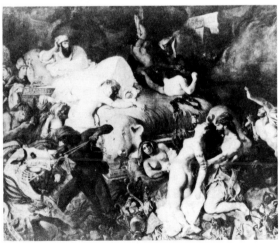

Fig.3 Inscr. "Sardanapalus after Delacroix", 1973, gouache and chalk on paper, 14½" x 22".

Fig.4 Eugène Delacroix, "The Death of Sardanapalus", 1827-8, oil on canvas, 155" x 195", Louvre.

cultural behaviour from early modern French culture. The epitaph on Sardanapalus' tomb supposedly read: 'I have eaten, drunk and amused myself, and I have always considered everything worth no more than a fillip.' Western culture had condemned these ethics as immoral and irresponsible. Sardanapalus, for example, is included in the background of the plate on 'Lewdness' in the 1758-60 Hertel edition of Ripa's *Iconologia* (fig.5), where he is represented as neglecting his male duties and as effeminate as well as degenerate. As a philosophical dandy torn between pleasure, ennui and spleen, Delacroix identified strongly with the positive image found in Byron's *Sardanapalus.* The developed model of 'dandyism' which descends from the 1820s to Baudelaire and beyond involved an existential despair and accompanying epicureanism, a spiritual aloofness from often tawdry circumstances. We can see aspects of this evolving and var-iegated cultural field still present in Hilton's case. Terry Frost, for example, recalls him as initially a 'snappy dresser' who shopped at a pre-1960s Carnaby Street[2], although he clearly 'let himself go' in these last years.

The publication of *Night Letters* in 1980 also revealed starkly the contrast between Hilton's reduced circumstances and yearning for spe-cial foods, his frustrations or various fears and his ability to transcend them.

Sardanapalus after Delacroix indexes Hilton to cultural themes of the feather-bed of debauchery and the philosophical 'dandy'.

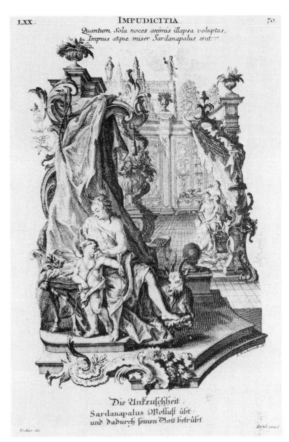

Fig.5　Plate 70, "Lewdness" from 1758-60 Hertel edition of Ripa's "Iconologia", Augsburg, 1760.

Historically what emerged from this in early modern French culture was a bohemian rejection of productive bourgeois life-style in favour of a disordering of the senses. Hilton more than once referred to the renowned aphorism from Villiers de l'Isle-Adam's *Axel*: 'Living? The servants will do that for us.'[3] Rimbaud, whose image of the 'Bateau Ivre'

You have a lewd mind.
The fun is over.
Vesti la giubba.
Get me the record with Caruso singing
it. I have asked you before.
You could have got it in London.
Beast!

View from the Sick-bed

Hilton admired and worked with (fig.47), went further and refused the very structure of work itself ('j'ai horreur de tous les métiers') and claimed the right to laziness (which concealed in fact a productivity not subordinated to everyday necessities). Similarly Hilton's career (especially his last couple of years) leaves an impression of disorder and casual production which, as we shall see, is belied by evidence of a high level of artistic productivity and certain serial or systematic aspects to that production. The view from the sick-bed was more serious and clear-sighted in one sense than our received image possibly suggests.

Let us turn to a literary text for a cultural model of heightened experience of the senses on the part of someone suffering from serious life-threatening illness. André Gide's *Nourritures Terrestres* (1897) had meant much to Hilton earlier in his life, and after he had settled in England again following nearly three years in a POW camp he was mentioning it as a book definitely to be read.[4] Gide's celebration of the 'fruits of the earth' is constructed around themes such as food, gardens, springs, cafés and farms. Gide celebrates 'the concentrated sensation of every

impact from the outside' simultaneously on the senses, while paradoxically affirming a sense of selfhood beyond a philosophy of sensationalism and at the same time losing that sense of self in favour of 'Vision'. Gide reflects thus on the circumstances of such visionary intensity:

> Don't you understand that the moment would not take on such incomparable vividness, if it were not thrown up, so to speak, on the dark background of death.

This was the comparable existential situation in which Hilton produced his life-affirming late gouaches with images evoking plants and trees, cats, dogs and animals, human figures and habitations, landscapes and seascapes. As Rose Hilton observed as early as April 1973, 'some of his stuff seems to get gayer and more vital with his increasing frailty'.[5] A friend asked him how he could produce such cheerful work given his circumstances, to which Hilton replied with a dismissive gesture something to the effect that 'there's nothing else left — what else have I got?'[6]

Fig.6 Ink and gouache on paper. [photo: Reg Watkiss]

Tracing Artistic Production

Hilton's first exhibition of his late gouaches took place in June 1973 at the Orion Gallery, Penzance, with 35 gouaches produced during the first half of that year. John Miller, who had recently had an exhibition at this new gallery opened by John Halkes, brought the gallery director in touch with Hilton.[7] The Sheviock Gallery had also been considering a show of his gouaches but could not do it at such short notice. There was no exhibition catalogue but a local notice mentions images of 'dogs, cats and occasional dinosaurs'. The first London showing of the late gouaches came at the Artists' Market that October, followed by the retrospective at the Serpentine Gallery in March 1974. A version was shown at the Scottish Arts Council Gallery in June-July (with 56 gouaches listed by comparison with the Serpentine's 21). His last show at Waddington's (Oct.-Nov.1974) included 35 gouaches.

Unfortunately this does not give us a clear picture of how many gouaches Hilton produced in his last two years. On the one hand, he claimed that 'since Dec '72 I have produced 3 to 5 gouaches a day'.[8] On the other hand, Rose Hilton has suggested that the production varied.[9] One gets no clearer picture of the number of gouaches executed from the number, around 110, which we can trace his having sent to his gallery.[10] Some time well prior to April 1974 he mentioned already having about 300 ready to show in a large gallery.[11] We need also to remember that his gallery's estate numbering alone reaches as high as 2008, although it is drawings which drastically increased the numerical level of his late oeuvre. The computerised stock-lists of works in Waddington storage are not specific enough to allow us to disentangle late drawings from gouache and charcoal works, but there are certainly hundreds of gouaches in Waddington Gallery's stock, though these vary in ambition, quality and state of completion. My count of only specifically dated 1973-5 gouaches from Waddington Gallery listings reached just under 450. Many works were also given away or stayed in his widow's possession.

We can be clear that in the couple of years prior to the start of the gouaches 'he painted erratically'.[12] For a complex variety of reasons — from that of personal health to loss of artistic certainty and typical mid-career problems of sustaining his work after the high point of the early 1960s — the late '60s and early '70s were productively thin. By contrast there is in every sense a generous abundance about his last two years' work. The sign of fecundity hovers over this work, not only reminding one of Matisse's 'love of creation' and the rejuvenation in his late work but also recalling Picasso, that other paradigm of French modernism in this respect. Hilton may just possibly have picked up some general idea of Picasso's late work

and its diaristic avidity.[13] Hilton even began numbering the month of execution in the last month of his life, suggesting some consciousness of the potential interest of his late oeuvre as human document in its handling of the full range of dreams and desires, delights and fears.[14] Hilton's late work certainly focuses on his own existential situation, his own ageing, loss of sexual drive and fear of death in a manner akin to late Picasso.

We can be certain about the difference in artistic 'behaviour' between Hilton's existential abstraction and his late work. The former implied a long internalization of experience and intensive short bursts of painting, at least at some point, even though other parts of the painting process probably involved more extended time and consideration. Terry Frost recalls visiting Hilton in his studio in the late 1950s or early 1960s at the end of a day and seeing him make a rapid decisive stroke after hours of cogitation. John Miller also remembers in the late '60s seeing him 'sitting with an oil for ages' while 'the energy was getting pent up'.[15] Instead of a sort of breathing in process and holding of one's breath prior to a decisive burst of singing, Hilton's late gouaches represent a continuous lyrical flow of images and mark-making.

To coincide with Hilton's Serpentine retrospective exhibition in March 1974, *Studio International* published the facsimile of a letter written to its editor Peter Townsend, with sections blocked out because of fear of libel. Reg Watkiss taped Hilton reading this letter in November 1973 as a lead-in to his semi-surreptitious recording of him reminiscing.[16] The painter Alan Green, who had a passing acquaintance with Hilton and had known Rose Hilton for a long while, was asked to interview Hilton in Cornwall, but on his arrival at the Botallack cottage was presented with the taped letter and was told that Hilton did not want to be interviewed.[17] Green then found the original letter and removed it, and the editor later obtained permission from Hilton to publish it in facsimile. Green added some further transcribed comments and a 1973 gouache by Hilton was reproduced on the magazine's cover.

We can conclude from this account that Hilton knew he was to be taped some time before Green's arrival and that he managed to circumvent this by having taped already his own more considered thoughts which he then allowed to be reproduced in their handwritten form. We can detect an alternating process of co-operation and resistance in operation here. Townsend's decision to publish an autographic version of the letter reflects his interest in Hilton as representative of English abstract expressionism.[18] Alan Green connects this interest with artworld politics about American 'cultural imperialism' and the claims of neglect and underpromotion by British painters of the same generation. Green further thinks that Townsend was particularly interested in Hilton because of his 'Ecole de Paris' grounding. However, Townsend may have felt the

need to acknowledge earlier models as then *Studio International* was dominated by post-minimalism and conceptual art.

One is inevitably reminded of the situation in John Fowles's *The Ebony Tower*, actually published by Jonathan Cape in 1974. Here a younger exponent of formal abstraction visits an ageing artist who represents 'the old green freedom' rooted in a celebration of the 'wildness...of the human body and its natural physical perceptions'. He feels challenged by the older artist's 'constant recasting' of himself and his 'not letting anything stand between self and expression'. Fowles's theme derives from a similar contrast of recent and earlier models of practice which lay behind the magazine's approach to Hilton.[19]

Hilton knew well enough that some final statement of his aesthetic position was required. However, he expressed his uncertainty about what was expected when talking to Reg Watkiss. In other words, Hilton felt pressured to some extent and we can expect the final letter to be carefully weighed up. Indeed, certain ideas crop up again in a letter to Peter Barton. Hilton mingles references to his artistic tastes with maxims on art-making and biographical snippets. The order is not logical and one senses that the letter accumulated over a long while. Its form embodies the free-association which characterised his gouaches, as when he states that he gets from painting 'a sort of soulagement' and then continues with a reminiscence of a visit to the Parisian painter Soulages, under-scoring both his interest in poetic rhyming and his French orientation.

Given then that the letter was a highly considered statement, we can assume that its effect of spontaneity is wrought, its free-associational form deeply wilful. Such form is inseparable from the content of what he says in communicating his outlook. Looked at this way, his libellous remarks also are undeniably intentional, and his asides to Reg Watkiss during his reading of the letter on tape show that he was quite aware of what the magazine would have to treat as potentially libellous.

Hilton proposes in the *Studio International* letter that he had developed certain strategies with his gouaches, avoiding painting in the absence of a clear mental image, painting 'as if you were painting a wall', being decisive about colour-application. None of these approaches actually turn out to be unique to the late gouaches as opposed to his earlier oils. However, his emphasis on working fast and consistently, and editing by destroying rather than altering, is specific to this phase of his work. The quick-drying quality of gouache allowed rapid working but its disadvantage for Hilton was its 'natural inertia' which necessitated in his view small spotting of marks to enliven the image. It was in this sense that Hilton was able to renew his work through the challenge of developing a new personal medium, though the overt incorporation of drawing into painting continued from his earlier oils.

Reality and Dream: From St. Just to the Midi

Hilton entertained an explicitly bohemian self-image from the start of his independent art-making. 'Bohemia' had been constructed in the nineteenth century as a notion of being at the periphery of metropolitan culture. So how did such a self-image square with a retreat to one far end of the country? Of course, 'bohemia' was a metaphor for alienation from dominant cultural and social values rather than merely physical location on the cheap degraded fringes of the metropolis, and part of that metaphor implicit in the image of the gypsy was a notion of lack of spiritual home. Hilton certainly identified strongly with that image, even though in literal terms he led a settled life. Moving to Cornwall signified retreat from metropolitan tensions and conflicts, and a desire to simplify his living still further. Clearly the association of 'St. Ives' with primitivist notions allowed an identification between a rather basic St. Just cottage and the topos of the bohemian garret.

Hilton was living literally at the end of the line (the railway line from the metropolis) and also facing his own extinction. One late image (ill.1) suggests Hilton's perception of his situation in these terms. Its spareness and configuration of a curved form going off the bottom edge recalls certain earlier works from the '50s and '60s. Two 'presences' in charcoal are placed beneath a red gouache 'headland'. The stylistic contrast of drawn shapes against painted form suggests a starkly elemental situation in which there was no distraction now from confronting the basic elements and starkness of one's existential situation.

Hilton's late gouaches should be seen as images constructed to represent his personal reality and dreamwork rather than transparent reflections of his domestic circumstances. Ill.2 seems to place two figures in 'rooms'. To what extent can one read an image like this as a picture of the bed-ridden Hilton and his wife in their isolated cottage? His second wife may well have often walked around the house naked but clearly that was not a determinant on Hilton's longer-standing involvement with the female nude image. We need to be careful in reading the reclining figure as Hilton because the prominent breast suggests that a female figure may have been in his mind initially. Yet the figure is recumbent and spotted, and Hilton's spotting of the image was possibly meant to denote his personal skin condition. The play of hot and cool colour here suggests separate spheres, with the discomforted artist in his own indoor space. Pictorial divisions can read as spatial cells which then carry overtones of psychological distance.

Sometimes simple domestic circumstances may have stayed with him. However, it would be simplistic to miss out on the imaginative and aesthetic transformation

involved. The tap in ill.3 locates us in the bathroom, but the rearing figure seems perched on a table-like construction, a grand dais of his own imagining. If the memory of his wife bathing became transformed into a different final image, again we cannot read an image of a child beneath a table (ill.4) in terms of everyday observation of family life. The play with scale leads us to adopt the child's perspective as the table becomes a doorway through to a sunlit beyond, topped by a black-centred 'sun' at the end of the 'path', a shape repeated in exuberant patternizing around the main opening. The table in front of the nude in ill.5 implies a child's playpen and the topmost pattern alternates as distant hillocks or sexual snake. The adult feels barred from the sexual arena, able to conjure up that delight only in images, reduced to the position of being a helpless child to some extent in his own eyes. Again this small cottage may have included a cat, whippet and another dog called Wogs, but his late gouaches of animals involve psychological projection rather than observed reality. An image of two dogs and their toying together (fig.7) feels as if it speaks more about his own partnership than about any pre-existent animals in the house.

Changed domestic circumstances led Hilton to play around with plans to revise their living arrangements and this personal diagramming was transformed into public images. His plan for a conservatory extension to the cottage (fig.8) becomes an ideal solar-

Fig.7 1973, gouache and charcoal on paper, 14⁷/₈" x 22".

ium overtopped with a perky blue bird and accompanied by a nude image named as his wife. Another plan for the cottage (fig.9) is divided into a cool left side with reclining figure and sun-drenched right side with seated figure, but whether we are viewing one total space or instead space(s) imagined at different times is unclear, and it also seems to fluctuate between surface and space, cross-section and plan. In fig.10, the cottage becomes a delightful chamber with plant and paintings, an ideal interface of nature and art, a frequent theme in the modern presentation of the studio from Matisse to Brancusi.[20]

It is fascinating that a childhood drawing book (Album C), used around the age of 12 while he was still at Northwood Preparatory School, had contained many plans of houses (fig.11) and that Hilton had later written in this album: 'In my younger years I dreamed and planned my ideal homes...my only real passion. I lived in them' (fig.12). Hilton was

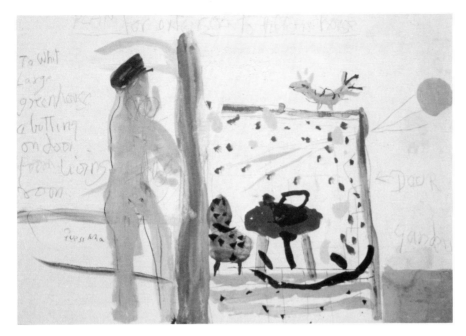

Fig.8 Inscr. "Plan for Extension to Hilton house" etc, pencil and gouache on paper, 15³/₈" x 22¹/₈".

Fig.9 Inscr. "Revised Plan for Hilton Dwelling", 1973, pencil, charcoal and gouache on paper, 14" x 22".

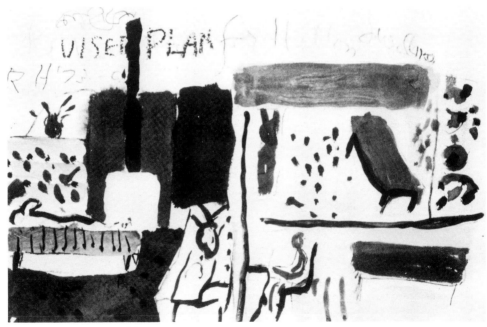

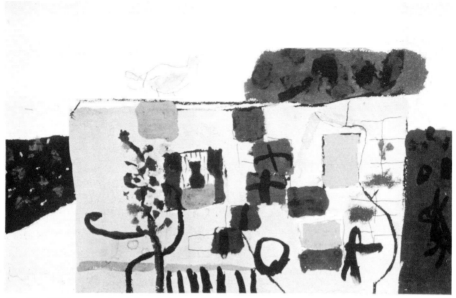

Fig.10 1974, gouache, charcoal and ink on paper, dimensions unknown.

Fig.11 Inscr. "13 of Jan. 1923", from Album C, pencil and crayon, 9¹/₂" x 14³/₄".

again imaginatively inhabiting his own pictorial constructions, though in a self-conscious poetics of space. All this is even more interesting when we realise that this particular album happens to be in Rose Hilton's collection. In other words, Hilton was going back over certain childhood drawing books still in his possession and making these marginal comments at the same point (as I shall discuss later) that he was consciously trying to represent a childlike sense of imaginative play and wonder in his final work.

However, there is a world of experience separating his childhood images of houses and these late images, a world of both image-making and lived experience. In fig.13, the cottage on the moor overtopped by gulls has become a simple rectangular plan with his presence marked in its top left corner. (Red patches in Hilton's late work often seem to mark instances of passionate identification) Or else we might read this rectangle as his bed of confinement (with head and erection located) or reminiscent of car fascia with needle (marking the time or speeding towards death?). Any attempt at such readings becomes caught up in the impacted signs of mark and pattern.

The great late image transfiguring his images of hearth and its relationship to the wider world (front cover) is replete with poetic analogizing and rhyming of form and colour. Two dwellings are separated by a 'tree' and overtopped by a range of 'mountains'. The bottom left circle refers to an aircraft propeller and hence to voyaging generally. We recognise how Hilton's decorative snake-pattern, with all its overtones of sexual attraction, can be transformed into hillocks here and at the same time (as with the other circular forms) suggest breasts, being colouristically linked with the female figure. Passion and excitement are evoked through the cultural associations not only

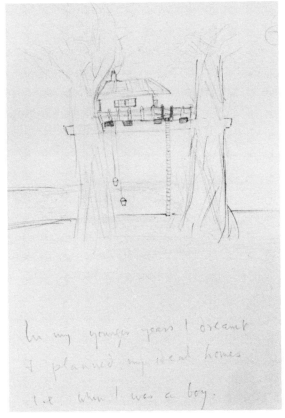

Fig.12 Detail of page from Album C, c.1923, pencil, 9½" x 14¾" (whole page).

of colour but also of 'open' marks, as much as by the sexual analogizing and poetic play with imagery evoking domestic pleasures and flying.

The last image presumably derived at one level from Hilton's final trip to the south of France in August 1974 (financed by an advance from his dealer), as described by Rose Hilton:

> We went to Antibes for a month, Roger ordering the local plane (coastal trips) situated a mile or two away, one morning to take us to France. We had to be ready in an hour. We did not take any luggage bar a plastic carrier bag with a whisky bottle and bathing suits. Roger, Bo aged 12, Fergus aged 8, and I went. It took seven hours, refuelling at Lyons. An exciting trip flying low seeing the changing landscape of France. Roger became cold and fractious towards the end of the journey. We stayed at a flat arranged for us very quickly by an old friend of Roger's, Brynhild Parker, who lived in Antibes. We set up more or less like at home, Roger staying in bed all the morning doing gouaches and drawings. I had to go to Nice and buy the materials. We ordered a wheelchair from the local hospital. He used to go down to the sea in the afternoons or early evening sometimes, watching a small circus that was there. In the evenings I used to leave him at the local café where he

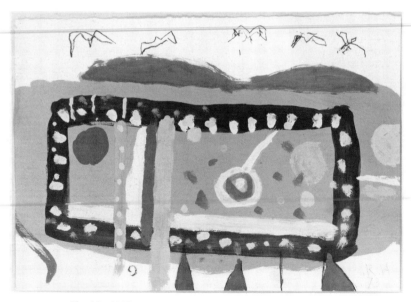

Fig.13 1973, conté and gouache on paper, 14½" x 22".

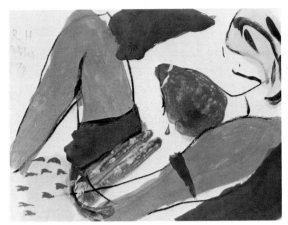

Fig. 14 Inscr. "R.H. Antibes 74", gouache and charcoal on paper, 10⅝" x 14½".

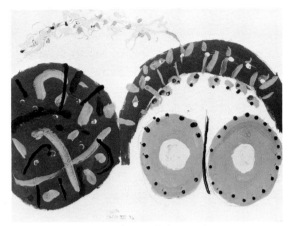

Fig. 15 1974, gouache and charcoal on paper, 19⅝" x 25½".

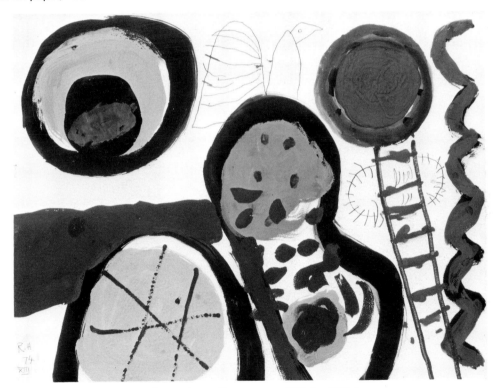

Fig. 16 Aug. 1974, gouache and pencil on paper, 19⅝" x 25½".

talked with fishermen and tourists. He was very good at French. Anybody used to push him home. I usually had gone to sleep by this time, and of course so had the boys.[21]

Return to the south of France would have evoked his first long stay there back in 1930. He had summered there last in 1962-3. The Midi had been developed as a high-society pleasure-ground and, conveniently near to Europe's great metropolises by rail, had been associated in the 1920s with 'high-life' and 'loose morals'. After the war, it represented a return to rich living (as in Elizabeth David's *Book of Mediterranean Food*) and an alternative to austerity Britain for those privileged to be able to make such a choice, though by the 1960s it was opening to mass tourism. Beyond its changing social reality, of course, the Midi was also a powerful myth of 'luxury, calm and sensuality', a dream of living in harmony with a paradisiac nature, and one literally lived out there by masters of the Ecole de Paris such as Matisse and Picasso.

The significance which Hilton attached to this farewell trip to France is indicated by the fact that a group of late gouaches have the place-name of Antibes added to the otherwise functional signature and year-date (eg.figs.14-15), sometimes with 'XIII' added (figs.15-16). Since this appears on more than one gouache,[22] it is more likely to be a scrambled version of 'VIII' (referring to the month of August) than a numbering system for order of execution. The work thus identifiable as done in Antibes ranges from images of creatures and birds in a bouncy setting with hints of hills and sea (fig.16) to single female sunbather (fig.14). Fig.15 reminds one of Karl Weschke's description of Hilton as an 'abstract Fragonard',[23] except that the turning of sexualised circles into a facing image — which features elsewhere in late Hilton — seems to reflect humorously on engulfment in erotic scopophilia. More generally the trip to the Midi reinforced the imagery of sea and nature, boats and nudes already central to the late gouaches.

Frustrations, Fears and Delights

Hilton's bed-ridden state and ultimately his death were caused directly by his drinking. Hilton noted that his annual consumption of whisky was 300 bottles [24] and he vaunted his increased alcoholic tolerance, even though this is the body's automatic reaction to help it cope. In his last days, Hilton described how 'the brain [had become] disordered, without rhyme or reason' and how 'every morning it is taking me longer and longer to recover' by means of what he called the 'medicine' of further drinking.[25] Hilton's second wife has described graphically the situation which resulted from his drinking in these last years:

Definitely by '73 he was more or less downstairs. He made light of it really. He just said he could keep his feet warm if he stayed in bed...He didn't really have much feeling [in his feet]. The doctor used to come around and give him vitamin B injections. The effect [was as much caused by] Woodbines [as drink]. He had 500 a week...He had flaky skin [and] got bed-sores on the elbows through leaning on one elbow and painting with the other...He used to rally up and say 'I'm not going to die yet, I've got more work to do' and be very cheerful.[26]

Alongside Hilton's cheeriness was also a deep misery at the end.[27] One gouache (fig.17) clearly reflects on his physical frailty and dependence on his second wife, though also suggesting the tenderness and pathos of moments of sexual fondling.

According to Rose Hilton, his life became unstructured when they moved to Cornwall in 1965 and the clear separation of work and rest, studio and home-life disappeared. In 1966 he had been committed to Exeter gaol after a series of drunken driving charges. This was followed by a conditional release in order to undergo treatment at St.Lawrence's Hospital, Bodmin. A couple of years later, he spent time drying out at The Priory, Roehampton. At some point, he expressed a definite desire to stop drinking, but by the time arrangements had been made with the nearest Alcoholics Anonymous at Par, he had changed his mind. Similarly there were plans for him to be admitted to Maudsley Hospital, London, where alcoholics were treated alongside psychiatric patients, but Hilton vetoed this idea definitively in June 1974. In one of the *Night Letters*, Hilton was still claiming that he was 'not ill' and was refusing hospitalisation, saying that he would 'feel like a hypocrite taking the place of someone who was *really* ill'.

Accounting for alcoholism is notoriously difficult. Rose Hilton remembers him drinking heavily in 1959 when they first met and his first wife traced its start back to the period after the birth of their first child in 1948 and

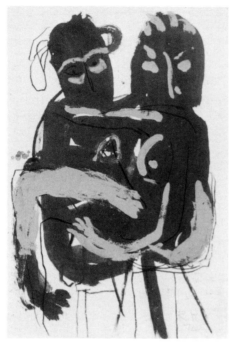 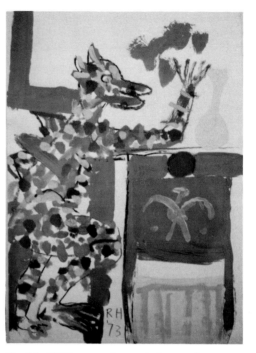

Fig.17 1974, gouache and charcoal on paper, 20¾" x 14¼".

Fig.18 1973, gouache and charcoal on paper, 12" x 15⅛-16".

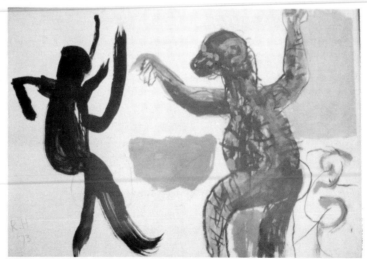

Fig.19 1973, gouache and charcoal on paper, 15" x 22".

difficulties encountered over painting. He had been supported by his first wife, who supplied the steady income with her music-teaching. This income was interrupted by the birth of children, which required sporadic employment on Hilton's part. Clearly this point in time involved intense pressure for someone who had survived on his father's allowance through his twenties, alternating between London, Paris and Dorset in a wandering 'bohemian' lifestyle not uncommon for privileged bourgeois offspring of this period.

In the late 1940s, having committed himself to art as a career as well as to raising a family, Hilton would have felt considerable pressure to succeed in this career, and he began quickly to identify with emergent vanguard norms and cultural issues. His first show of 'tachiste' paintings (fig.35) at Gimpel Fils Gallery in 1952 was quietly successful in terms of sales and critical notices. His second exhibition there in 1954 of 'neo-plastic [work] with expressionist overtones'[28] led to considerable peer-recognition and some social esteem. Yet this period, according to his first wife, saw the start of his abusive drunken behaviour, which reinforced his social reputation. Hilton clearly had difficulty in handling the pressure of expectation and the sense of internal conflict which he felt about being appreciated and getting attention.

We have some important glimpses of what his drinking was all about when we consider his boorish behaviour on the occasion of being awarded first prize at the 1963 John Moores Exhibition or his producing a bottle on the occasion of the royal introductions at the opening of the Tate Gallery 1964 exhibition, *Painting and Sculpture of a Decade*. We know that it was after he received his CBE at Buckingham Palace a few years later that he refused to continue his treatment for alcoholism at Roehampton and resumed drinking. Again we can see clearly how 'success' set up some sort of inner conflict.

At the risk of moving into irredeemably lost realms of private emotional experience, my own surmise is that 'success' did not bring undemanding love for Hilton but instead set up conflict, and that this pattern went back to his childhood. There is enough documentary evidence to state that his parents regarded him as a disappointment in various ways. In the eyes of his doctor-father, he was not a strong healthy child and was a 'failure' in academic terms, unable to follow his elder brother to Marlborough and Oxford, packed off to a minor public school (where he was acutely unhappy) and then fitted up (via his art-trained mother) with a place at the Slade. Parental love must have got connected at some level with approval. Hilton resisted his mother's personal investment in his progress at the Slade by going off to the Académie Ranson in Paris in 1931 before he had got his diploma at the Slade, and parental pressure on him to be 'responsible' continued through the 1930s. My

guess is that at some level Hilton did not feel 'good' about himself and that this need for approval simply produced more internal conflict.

All this discussion assumes that drinking has the function of numbing deep pain, and I need to acknowledge that many researchers see psychological difficulties as the result rather than the cause of alcoholism. Certainly the drinking itself gave rise to further conflicts. However, Hilton certainly responded positively to the notion dominant in the mid-1960s that alcoholism was a symptom of emotional problems. In his annotated copy of the 1965 Penguin text *Alcoholism* by Kessel and Walton, Hilton was clearly fascinated by the section on 'the neurotic alcoholic' describing how such alcoholics drink to diminish emotional conflicts. Hilton inscribed 'I am neurotic' quite simply in the margins and also marked the following passage on p.87:

> The relationship with the mother has much to do with the sense of security in later life. The oral personality seeks throughout life to find those maternal comforts which he lacked during infancy when they were so necessary for secure emotional growth.

Hilton's annotation of this passage reads simply 'what I've always said'. Although it is not clear as to what Hilton had 'always said', he obviously connected his problems to how he was responded to as a child.

Without the cultural validation of drink, however, Hilton's difficulties could well have been expressed differently. The idea in western culture of the relationship between alcoholic intoxication and artistic creativity developed as a response to the emergent notion of the difference, exceptionality and cultural resistance of the artist, culminating in the transcendent imagination of the Romantic artist-genius. In the next generation, Baudelaire's 'Le Poème de Haschisch' suggested that 'the world of the spirit opens up huge perspectives, full of new glimpses' which could be re-created by drugs and alcohol, a view shared by Rimbaud, Verlaine and countless others. Hilton identified strongly with such early modern French writers but in more local terms heavy drinking was also associated with the Neo-Romantic bohemian circles around Fitzrovia pubs in the 1940s (Dylan Thomas, John Minton, Colquhoun and MacBryde, Gerald Wilde and so on). Again the connection was made between intense, inspired art and the creative 'sustenance' of alcohol, and this link was maintained through the 1950s in different British modernist circles wherein the cult of 'macho' fighting was as dominant as we know it more famously to have been in American abstract expressionist circles.

Certainly existential abstraction such as Hilton pursued from the mid-1950s seemed to necessitate a state of high tension and anxiety which was difficult to sustain on a

Frustrations, Fears and Delights

workaday basis. As well as the question of sheer ideological discomfort, there were also real pressures of cultural competition, market demands and critical expectation. Self-destruction was part of the cultural script of alienation and existential responsibility of the fifties avant-garde, best remembered in American cases such as action painters, jazz musicians and beat poets who destroyed themselves in a vicious spiral of overwork, drink or drugs, and life-threatening behaviour. Terry Frost recalls Hilton experimenting with mescalin, playing 'chicken' with Bryan Wynter while driving along the roads near Zennor, and saying at one point 'I'm on the primrose path to destruction'.

Indeed, given the romantic investment in the equation of drinking and creativity, perhaps it needs stating explicitly that alcoholism probably had a deleterious effect on both Hilton's human relationships and also his work by the time the disease had really taken hold in the second half of the 1960s (leading to a lower income from his dealer than need have been the case). Alcoholism finally produced memory losses, insomnia, physical deterioration, misery and death. Hilton was still able to raise his human spirit in bouts of good cheer and to rally his creative powers sufficiently in a remarkable burst of creativity. What, therefore, we need to celebrate is human creativity in the face of the debilitation produced by alcoholism and not bohemian colourfulness deriving from a culture of intoxication.

One late image (fig.18) seems a reflection on his own addiction. A spotted creature reaches avidly for a yellow flask, resting on a cupboard with what could be a trapped bird inside. An image of a reclining figure overlaid with spots has been discussed already (ill. 2). This spotting arises from the decorative variety of marks which Hilton developed, but also suggests a projection of his own situation of physical discomfort, deriving from his skin condition.[29] Another spotted creature suggests a bear who dances with a female black figure (fig.19). The bear is a traditional symbol of gluttony, but clearly one cannot read traditional symbolic meanings such as this within modern culture when the shared symbolic codes sustaining such symbolism have collapsed. That is not to say that there may not be vestigial or generalized associations which images carry, such as brutishness. If the figure resembles a prehistoric animal rather than a bear, the suggestion may be of a creature facing extinction. The scuffed paintmarks in the lower right certainly suggest question-marks.

If the colour black here suggests a dance of death, elsewhere horizons and blank spaces imply meditation on annihilation, as in the black bird falling to earth in fig.20.[30] One gouache (on title page) provides his own epigraph for any discussion of these gouaches. The wording 'The Last Days of Hilton' is locked inside blocks which suggest forms against space. Its visual centre is a red spot located in a black dwelling. The markings

suggesting track (as if triggered by certain late gouaches with railway images) imply an end of the line in the black shed of death. One is reminded of one of the rambling late letters: 'Timbucto, the Bakerloo line. I am the chief. The run-in towards death.'[31]

One 1974 gouache (fig.21) recapitulates the 'tree of life' image, dancing against an intense orange ground. There are hints of a figure along the bottom layer with its unpainted ground. A tiny boat bobs between what could be read as male and female sexual parts, below the blue band of the sea. The prone figure is identified with the element of earth, but the grander pattern of life continues, the colour of the element of fertile earth transferred to the whole sky. In other late gouaches, an exotic tree pushes to the edge of the whole picture-space, half obscuring a naked female in a contained area in one corner (fig.22), or else a black tree above a 'ladder' is surrounded by a family of three forms (ill.6). A knackered spotty old horse has a loose question mark around its end and a piece of vegetation already springs from its back (fig.23). His last gouache (fig.24) represents a plant form sprouting from a brown presence. Clearly these are meditations on the relationship between human consciousness and organic life in the context of impending death.

One late 'Night Letter' apparently found

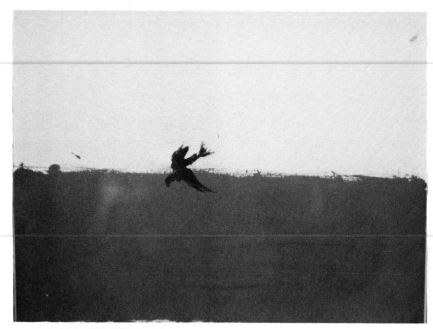

Fig.20 gouache, ink and spots of pastel and conté on paper, 10" x 13½".

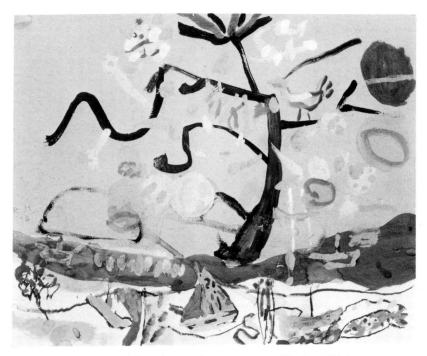

Fig.21 1974, conté [?] and gouache on paper, 15⁹/₁₆" x 19⁷/₈".

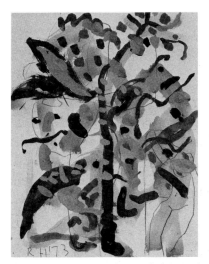

Fig.22 1973, gouache and charcoal
on paper, 17¹/₂" x 13¹/₂".

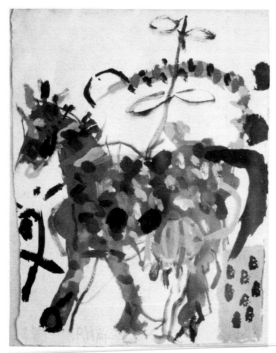

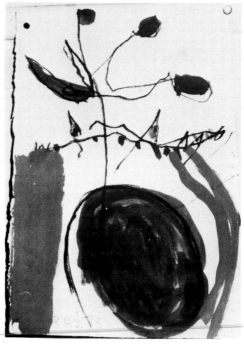

Fig.23 1974, pencil, gouache and charcoal on paper, 16³/₄" x 13".

Fig.24 Feb. 1975, gouache and charcoal on paper, 18¹/₄" x 13¹/₄".

under his death-bed (fig.25) unexpectedly quotes the psalms in a mood of acceptance of death, with a rather pathetic snake underneath. His mind flashed to the image of paradise and a reclining but bouncy female nude dominates the sheet. At the same time a children's rhyme comes to mind based on this image, and one suggesting physical arousal ('pinch me'). The shift of sentiment and tone is swift and sparkling. The snake, as well as being a cthonic (and hence destructive) image, is obviously a phallic one, associated in Christian culture with the fall. As well

as mediating between the themes of death and sexuality on the same sheet, it seems to connect with the 'comforting staff' image as well as being a projection of personal sadness. These feelings he acknowledged in a newspaper interview with Frank Wintle not long before he died.[32] Wintle also seems to be reporting Hilton saying that 'like Picasso in his later phase, he was displacing into art the emotions that old age had siphoned out of his life - notably the erotic'.

Sexual impotence led to pictorial wishful thinking. The role of the image as gift of love

(going back to his first greetings cards for his mother) takes on poignant form in fig.26. This supposedly 'iconic' sign is inscribed 'To my darling prickless wife'. Elsewhere a crane erecting its gantry with difficulty may express metaphorically the same frustration. Urgent sexual needs are expressed more directly in yet other images of erections.[33]

One doodle in the *Night Letters* (fig.27) can be used as a point of access for exploring the issue of how far we can read Hilton's late images. A reversed variation of bass clef could be seen as marking an existential question. This same configuration on the left appears in one gouache (fig.28) which perhaps suggests the bent-over figure of the artist before a youthful female figure. If Hilton associated this sign with himself, the left form with a dot in fig.27 could be read as a side-lined interrogative figure. Since the central note is accompanied by another question-mark and surrounded by two shorter notes, we *could* read this image as a question about his fate (or even replacement). Does this make this evidently cryptic play with the look of a bar of music a disguised family group?

Certainly in the late 1940s Hilton had moved from poetic figuration to reducing figures to elemental marks and forms. One image shows a transformation from family group to painted sign (fig.29). It is also true that Hilton often toyed with the spectator in inviting a figural reading in his mature oils.[34] Moreover one late sheet (fig.30) represents a silhouetted head associated by colour with the earth, a plant opening up and two smaller burgeoning growths. It is difficult not to read this as picturing the artist looking on his young family from a position anticipating his own death and return to the earth.

Consider the example of Hilton's penultimate gouache (fig.31). This has been interpreted by David Brown as a 'family portrait'.[35] One becomes trapped in the typical discursive closure of saying this is what this otherwise abstract-looking image *really* is if properly grasped. Working against such closure, though, we could add that the double-arc form appears constantly in Hilton's gouaches and earlier oils, often evoking cleavage or rhyming with wing or landscape forms. The configuration of this image could indeed be read as an exploded single female figure. Colouristically the pairing of orange and black could be read as a contrast of eros and thanatos. None of this is to deny that at some level Hilton may have played with the notion which David Brown suggested in this family of forms.

To say all this is actually to underline the act of faith involved in accepting any such artistic projection or act of commentary along these lines as 'valid'. The conditions of reading modern art images at all and the conflict of artistic impulses therein are thereby underscored, but it cannot be denied that one of Hilton's impulses was clearly to transfigure formal elements into an embodiment of his existential situation.

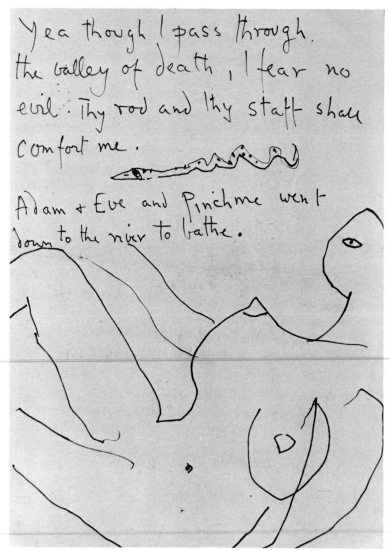

Yea though I pass through.
the valley of death, I fear no
evil. Thy rod and thy staff shall
comfort me.

Adam + Eve and Pinchme went
down to the river to bathe.

Fig.25 Ink on paper, found under Hilton's death-bed. [photo: Reg Watkiss]

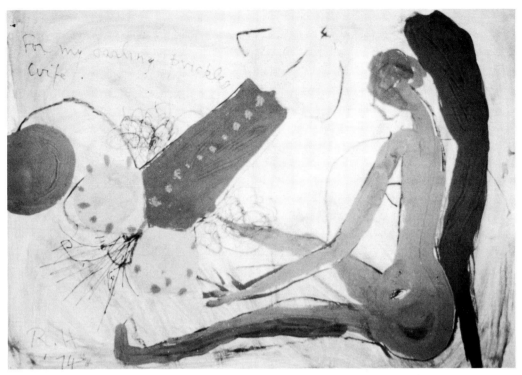

Fig.26 1974, pencil, gouache and charcoal on paper, 13½″ x 19½″.

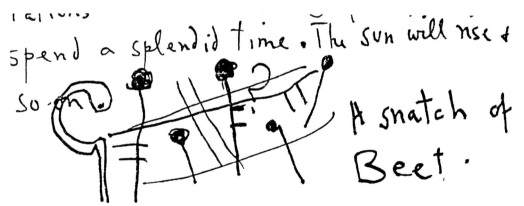

Fig.27 1974, detail of *Night Letters* (1980), p. 177.

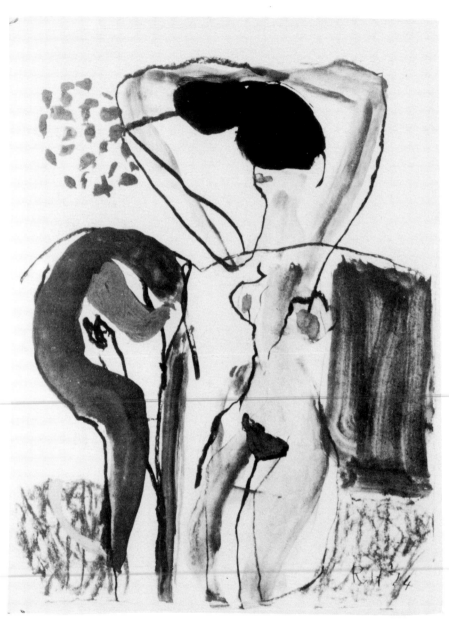

Fig.28 1974, pastel, gouache and charcoal on paper, 16¼" x 12¾".

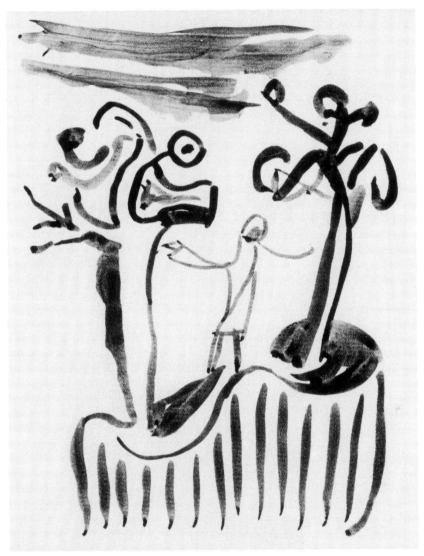

Fig.29 c.1949, page from Album N, ink, 7⅝″ x 6¼″.

Fig.30 Conté and pastel on paper, 8" x 10".

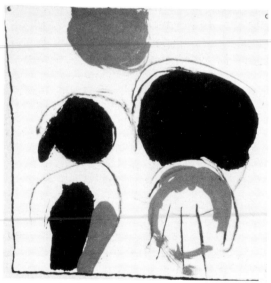

Fig.31 Feb. 1975, gouache and charcoal on paper, 17³/₄" x 18¹/₄".

Abstraction and Figuration

Texts on Hilton tend to imply that the late gouaches were the end-result of a drift away from abstraction towards figuration which had started in the late 1950s and had become more overt from 1961 onwards. Since Hilton himself talked about wanting to 'reinvent figuration' in his 1961 Galerie Charles Lienhard statement, where is the problem in this general notion of a turn to figuration around 1961? Firstly the chronology is more complicated than this picture presents. Secondly discussion of this turn to imagery often misrepresents the working of the figuration in terms of a new post-modern permissiveness, a pluralist choice of abstract or figurative elements as the artist saw fit. This was not at all the spirit in which Hilton deployed imagery, and how the spectator is handled by the painted image needs careful consideration.

Hilton had turned to abstraction only at the age of thirty-eight and his painting practice over the previous two decades is still almost unknown. Fig.32 can stand as representative of aspects of his 1930s developments. Its confident use of thin oil-washes and summary drawing exemplify at its best the qualities of spareness and elegant charm learnt from Bissière at the Académie Ranson in the early thirties, while its interrelation of open drawn mark and coloured patch indicates the development of his painterly confidence probably by the latter part of that decade. It also reflects that pursuit of the sense of wonder in childhood which returned as an explicit theme in his last years.

Around 1960, Hilton described his artistic programme in the 1930s as using 'painting [as] a means of attaining...[the] Ideal'. In the late 1940s his artistic practice was still fixated on a poetically ideal world of arcadian and primal imagery, romance and child-like joy mingling delight with yearning and melancholy. In Album W (1947-50, British Museum), he talks about his search for beauty and he refers explicitly to Keats' idea of 'the holiness of the heart's affections'. He praises Douanier Rousseau for his great poetry, and indeed Hilton was writing scraps of poetry during this period, sometimes with images appended. In fig.33, for example, an image of artistic pearls being cast before swine is counterpointed by images of animals and women, a line of female hair becoming the tightrope against which a floating nude is set. Other notebooks contain pages of proliferating images. One page from Album M (c.1946-8) includes model train, boat, carriage, bicycle and playful post-cubist figure-and-furniture images along with biomorphic and phallic 'esprit' (fig.34).

Hilton's immediately post-war figuration then involved an ideality of image, while his turn to abstract tachisme (fig.35) was partly based on a sense of greater vividness engendered by such painting. By the early 1950s he

clearly felt that imagery precluded a sense of intense reality in painting. In an undated text entitled 'The Way of the Rejection of Images', imagery was described as stultifying, precluding the expression of 'Romantic passion', and obstructing the total impact of the painting, the role of which was described as 'health-giving "lung" enabling the spirit to breathe'. The rejection of images for Hilton enabled the painting 'to link itself at once with two things which are of the greatest moment to us - space and time'.

Hilton's trip to Holland in 1953 led him to confront the work of Mondrian. This and his association with the Dutch artist Constant led him to squeeze out shallow space from his abstractions, to work from the totality of the painting and to combine this holistic sense with an implication of extension beyond the pictorial field. Works such as *January 1954* (fig.36) are the result. For all its debt to Mondrian, it has an aggressive lumpiness that takes us out of a world of higher harmonies and thrusts a more pressing world of unpredictable shapes in our face.

Another text in Rose Hilton's possession is Hilton's pithiest exposition of abstract expression. Paintings were described as the 'meeting place of opposing forces' balanced 'not so much through design in the accepted sense but according to laws of strength'. Thus would a painting partake 'in some way of a physical reality'. Shapes would be a 'particular quantity of a given colour with a given vibration'. These colours would be vital presences or 'personalities' in a pictorial drama. However, when one realises that Hilton intends visual weights and forces to create the illusion of physical ones, the aesthetic problems involved in talking about paintings as physically 'real' are exposed. Since this case involves everything that is the world, one is actually talking about visual forcefulness rather than physical reality.

Such a programme aimed to revoke that distance between artist and audience created within modern culture by sheer impact on the spectator, with no role of culture as intermediary. Yet the spectator is confronted by a difficult artwork which resists being consumed via any of the strategies conventionally deployed in appreciating art (reference to the visual world, association, the artist's personality, or even delectable paintwork). That difficulty was held to confirm the privileged power of art by contrast with mass culture or more consensual artistic taste. Such difficulty was seen as the proof of culture's 'being', of human resistance to claims made upon one's humanity and the reception of such work testified to the dilemma of the work's effect of intimidation producing a dumb response.

Hilton's 1961 statement for the Galerie Charles Lienhard posits a choice for an abstract painter between turning to architecture or reinventing figuration. Such a statement was a reworking of earlier ideas and indeed the choice was one which Hilton felt acutely, but around 1954-6 rather than

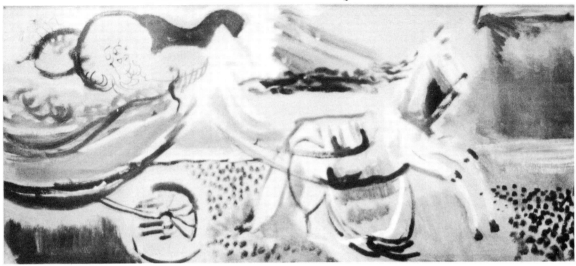

Fig.32 1930s, oil on canvas-board, 8½" x 9¼".

1961. On a deeper level, it was a question of what felt emotionally convincing, and this dilemma was triggered by a marriage crisis following an instance of infidelity. Indeed the reappearance of images in his work does not start in 1961 but goes back to the mid-1950s. Fig.37, though undated and untraced, appears to be from this period on stylistic grounds, though a set of destroyed imagistic paintings may have been produced even earlier in 1954/55.[36] Its human imagery is nightmarish, a frightful head atop a lumpish torso upheld by spindly legs, the head chastened by exposure to the body's urges.

This problem of making painting emotionally convincing needs to be framed by a reading of the ideological closures of the Cold War and the consensual culture of a booming capitalism by the late 1950s. In such cul-ture, as Michel Leja has recently explained,[37] 'reality' was invested in new constructions of the human subject which were deeper and broader than the nineteenth century, with its emphasis on rational centring and a moral economy of thrift and industry. The new model was less centred, less means-ends oriented and characterised by layers of thought and emotion. A sense of extreme human subjectivity alone seemed real when other social ideals (such as those deriving from post-war reconstruction ideology) seemed compromised or unconvincing. A note by Hilton makes it clear that the key problem for him at this time was not in fact a choice between architecture and painting (which was a rhetorical device for market consumption) but the sense of some emotional authenticity:

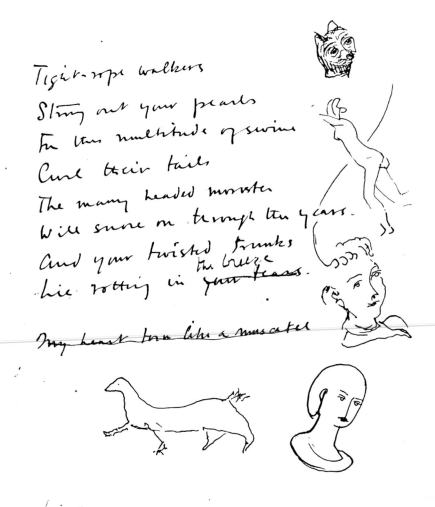

Tight-rope walkers
String out your pearls
For the multitude of swine
Curl their tails
The many headed monster
Will snore on through the years.
And your twisted trunks
Lie rotting in the breeze.

My heart torn like a muscatel

Fig.33 c.1949, from Album N, ink, 7⅝" x 6¼".

60

Fig.34 c.1946-8, from Album M, ink and watercolour, 14" x 9".

Abstraction and Figuration

The central problem at the moment is to re-introduce figuration without making it descriptive. Figuration not because we particularly want to figurate but because the picture must be geared to something outside itself.

Such a figuration would have to be freely developed without consideration of the visual logic of any pre-existent reality, indeed setting the logic of the medium itself firmly first. The figure had to be generated from the demands of the painting. The shape-language of fig.37 is similar to other abstract paintings, sweeps of knifing constituting the 'torso' area while dry brushing suggests the 'belly' and extracts the 'figure' from the painted field, tubing picking out the spindly legs. If the imagery of such work seems painful, figural suggestions in other works might be more inviting as far as the spectator was concerned. In one mid-1950s piece of writing in Rose Hilton's papers, Hilton talked about wanting to 'ravish the senses', 'to eradicate the harsher and more unpleasant aspects of my work and replace them by winsomeness and charm'. Yet however much the figural suggestion might win over the attention of the spectator, experience of the work finally returns us to the manipulation of the medium itself. Fig.38, for example (an undated painting related to a set of square late oils on hardboard) creates a sheer sense of dionysiac energy, with an interplay of drawing and painting around the face and buoyant hair. Yet one leg is missing, replaced by a green prop underneath the exaggerated bottom, and despite the evocation of a female figure, we are returned to the surface of bare hardboard in places.

Hilton's figurating involved a divided impulse towards involving the spectator through association and resisting the invitation to read away from the mark and shape to some discursive realm of meaning. Indeed Hilton's post-1961 oils were still split between explicitly figure-based images and often extremely reductive abstractions, and this was more true of his late gouaches as well than is often realised by those who know only the more winsomely figurative of them. His late gouaches share a similar dialectic of winsomeness and resistance to easy consumption, figurative readability and opaqueness to penetration, discursive movement beyond the image and focus back upon the material and formal constitution of the artwork.

Indeed Hilton's figurating in his late work is (like Guston's) as 'modernist' as his abstractions. Too often analyses of modern art are more cogent in explaining the operation of abstract rather than figurative art or else recent reversals of the previously dominant model of artistic development from figuration to abstraction are constructed as post-modernist rather than incorporated into the development of modern culture. We need to analyse precisely what is involved in naming Hilton's figurating in his late gouaches as 'modernist', and to analyse how it operated in relation to painterly mark and shape.

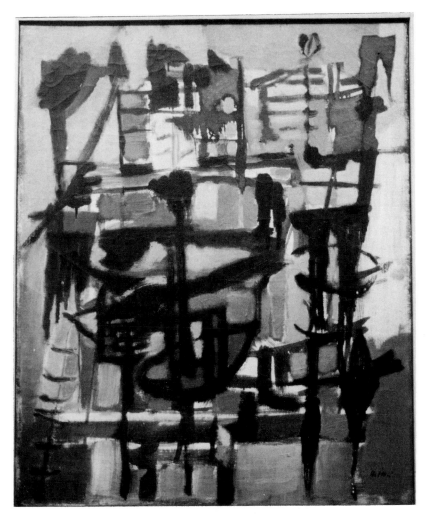

Fig.35 "Composition 1", c.1950-2, oil on canvas, 26" x 22".

Fig.36 "January 1954" (previously titled "January 1955"), oil on canvas, 36" x 30".

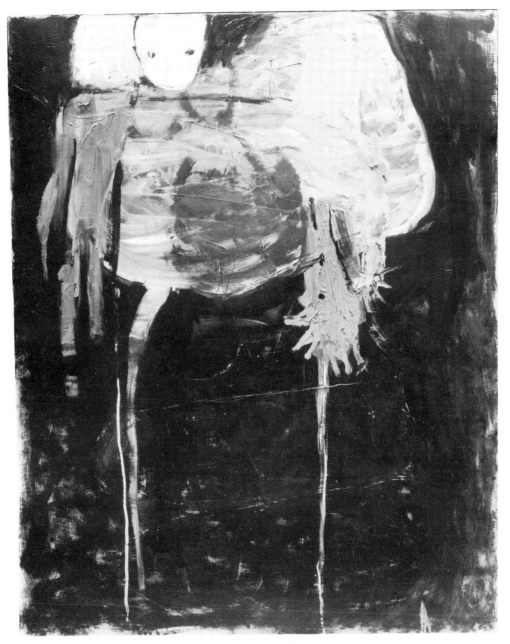

Fig.37 Untraced painting. [photo: Roger Mayne]

Mark, Form and Image

Let us begin by looking at Hilton's 'medium' and what that signified. By 'medium' I mean here not a given material process with 'naturally' associated aesthetic qualities but instead that personal reorganization (or 'distortion') of given conventions which typify modern artists' creation of their own personal medium to pursue particular possibilities. Hilton's late gouaches should really be called 'charcoal-and-gouaches' since most rely on some relationship between drawing and painting for their aesthetic operation. This 'invention' carries over from Hilton's incorporation of charcoal into his oil-painting, which began to appear decisively (rather than as trace of under-drawing) from 1956 onwards and to operate significantly from 1959. This relationship between drawing and painting within the arena of painting itself generates meaning within western art conventions. The western academic tradition had given priority to *disegno* understood both in terms of the planned process of constructing a painting and also as embodiment of idea or intellectuality. Venetian *colorito* as opposed to Florentine *disegno*, or *coloris* as championed by the late seventeenth century French academic 'Rubenistes' in opposition to the *dessin* upheld by the 'Poussinistes', connoted the life of the senses and the shifting natural world. Such values were construed as a threat to the world of mind and order.

In a few late gouaches one ground colour brings forward the initial drawn image or parts of it, dictating a calmness and clarity of image. In ill.7, a nude drawing is 'reserved' by the blue sky, though the green field below (with its leap of scale in the animals and its bucolic humoresque in the sexual connotations of the field-shape) becomes a positive form against a white ground which is continuous with the female figure in the top left. In ill.8, drawing and painting are completely separated as zones and contrasted in their qualities of medium, while ill.9 was worked over a preliminary drawing but emerges as a painting of almost oriental exquisiteness. Very occasionally the colour areas are minimal (ill.10) yet add erotic charge to the architecture of clumsy fleshy parts. The colour-patches here attach themselves loosely to the drawing yet seem to resist entry into the image in favour of restoring tension across the surface.

Normally there is more painting over drawing or else painted marks play with the underdrawing in some dynamic relationship. In ill.11, the female body becomes the starting-point for rhymings of open and closed shapes around it, while the initial drawing is left fully exposed only in the devalued head-area. Sometimes within one image there is a varied play between drawing and painting. In ill.12, only one of the loops at the top is painted up to. The serpent/dinosaur and dec-

orative forms emerge over the lower drawing while an arcing arrow mark at the top reappears as a more tree-like painted form below. The clash of marks produces a sense of lumbering movement at the bottom while the painted-in green form top left becomes an object of desire to which the bird gazes and arrow points, rhyming in its angle with the sexualized tree-form to the right of the red disc. Blobs and scuffed strokes dominate over the drawing in ill.13. The right side is coloured over and painted bands and marks radiate upwards from the bottom edge, creating a turning movement and sense of abundant natural activity. In ill.14, autonomous circular marks even smother the initial overpainting of drawing by the elephant form. Vestiges of drawing at the edges of this images simply add to the suggestion of movement.

From within the codes of western artistic culture, to smother drawing with colour means to signify the triumph of a disorderly sensuality. The painted mark came to connote more specifically by the nineteenth century the registering of fleeting natural effects normally reserved for the oil-sketch or else shifting authorial consciousness. It is in this way that marks in gouache are read as signifying Hilton's 'exuberance' or the delight of the scene being evoked. The evidence of underdrawing also reminds us of that deployment of conscious pentimenti in his oils or else their evocation of the changes characteristic of the sketch stage of working.

Hilton shared in that mainstream modernist desire to signify in his 'finished' work an 'unfinished' temporariness of configuration and relationship culturally connoted by the 'sketch'.

Hilton developed a system of decorative marks and patterns over and beyond the 'pointillisme' to which he referred in the Townsend letter. Spots become larger scuffed marks or extend into short arcing or straight strokes, bars or waves. Surrounded by circles, they suggest nipples or eyes, elemental organisms, wheels or fruit. Waving lines can suggest lines of breasts (front cover and ill.5), snakes (ill.5), with their sexual and earth-bound connotations, octopus (ill.20), hills (front cover), or rising sea (ill.17). The rhyming of wings, female body-shapes and sea can be found in various works. One late gouache (ill.15) has a visual wealth of spots, arcs, bands and blobs in four colours suggesting breasts, stomachs, and legs. A domestic animal acts as surrogate viewer for this witty play with erotic obsession. The connotations of blue sea and sky key us into an imagery of rolling galleon with pennant and cannon puffs, bringing in a level of humorous association between body, vessel and elements. In ill.16, however, it is more difficult to say what image comes to the fore. Stripes, circles and triangles play around a dark centre, held together by an economical underdrawing which comes back over the top red ochre. Balanced on a striped surface, it looks as though a still life is suggested but

Fig. 38 Oil on board, 48" x 48".

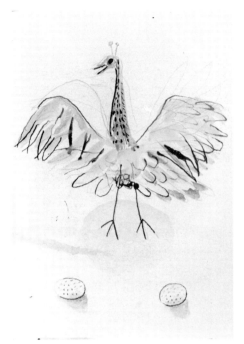

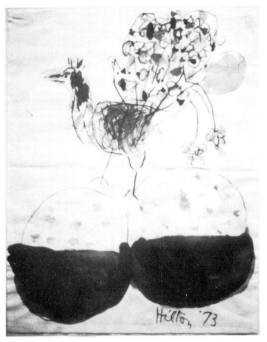

Fig. 39 c.1939, from Album G, pencil and watercolour, 8³/₄" x 6".

Fig. 40 1973, gouache and charcoal on paper, 9⁷/₈" x 7⁷/₈".

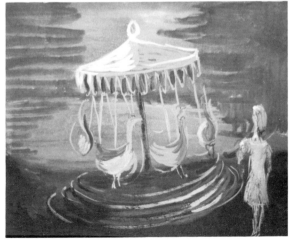

Fig. 41 Late 1940s, gouache on board, 10" x 12¹/₂".

triangles suggest boat imagery, perhaps with figural overtones (setting sail in a wheelchair?).

Thus Hilton developed a pictorial system in which decorative marks were able to ascend to the status of imagery or sink back into pictorial form in the spectator's eyes. This is the way in which I envisage image and medium coming together most typically in Hilton's late gouaches, that is, on a range of levels within each painting. Overall the flow between image and mark involves an invitation to curious spectatorship by creating different degrees of semiotic readability within the one work. In other cases we are left with a blandness or flabbiness of mark alone or an undemanding imagery. Sometimes the imagery can be so consistently ambiguous throughout the painting that we struggle to gain a purchase on it at all. One is tempted to say that such works are not as 'good' as the former. However the different approaches clearly reflect Hilton's divided impulses towards difficulty and winsomeness, resistance to discursive reading and desire for clarity of reading.

Circles and arcs can suggest sexualized forms while springing into an overarching guardian bird (back cover). In other images the birds are more pathetic[38] or more schematic, rhyming with boats in seascapes or contrasted with an orthogonal layout implying cliffs.[39] Sometimes schematic but threatening birds overtop sexualised cliffs and crevices.[40] Their arcs can rhyme with the landscape format and remind one of female body forms (ill.17). Pairs of birds can connote sexual partners (ill.9). In other contexts birds represent spiritual going on despite physical decrepitude,[41] imaginative flight or death (fig.20).

The bird image on its own needs to be seen as involving the artist's identification with the image. Fig.40, for example, presents a peacock whose symbolic associations with 'superbia'[42] may have disappeared but which suggests an analogy of display of visual delight (connected with sexual excitation) still apposite to the art of painting. The lower part of this image recalls the forms in countless earlier oils while images of birds had appeared in his early work. Album G from 1939 and later, which Hilton still had in his possession in the cottage and could easily have referred to, contains faux-naif images of birds with magnificent raised wings. One relevant page (fig.39) shows a peacock hovering above two eggs. The enlarged scale and 'cupping' of the circles in the later gouache suggest the deliberate operation of erotic projection.

Hilton worked from a variety of reference material as well as observation and memory. He had a wooden bird in his studio [43] and also encouraged friends and book dealers to bring or send books for reference.[44] He also had some earlier images around or lodged in his memory bank. Hilton emphasised in the March 1974 Townsend letter that he 'dredge[d] up bits from the past...above all,

past paintings'. We have just looked at one instance of this active recall. Images of fairground and circus were frequent in his work of the late 1940s (fig.41). One 1974 (fig.42) gouache treats the merry-go-round as a wheel of human life from which the confined creature at the bottom is poignantly removed. I have referred already to various images of horses in Hilton's late work (fig.23). This was another image used extensively by Hilton in the late 1940s, although he fed his memory-bank also by referring to his copy of Anthony Dent and Julian Hall's *The Horse Through 50 Centuries of Civilisation* (Phaidon, 1974).

The 1980 Graves Art Gallery exhibition of Hilton's late gouaches was able to assemble five images of carts, usually with figures, and more can be traced.[45] This image goes back to the 1930s and fig.32, conceived within an aesthetic of faux-naif 'wonder', was possibly based on the childhood horse-and-cart (fig.43) which he still had in his possession at the end of his life. (In actual fact, the horse and cart were separate in origin, as their relative sizes confirm.) The horse-and-cart image was especially common in the late 1940s in Hilton's work (figs.34,44). Fig.44 pictures a mean carriage against a grand classical facade, suggesting Hilton's self-image as a 'vagabond at heart'.[46] Given Hilton's keenness to improve his housing situation at this time and his relatively settled mode of existence, this image of himself as unsettled nomad must be read in terms of

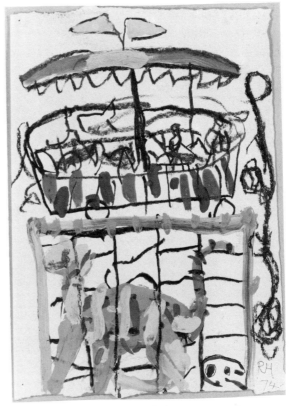

Fig. 42 1974, gouache and charcoal on paper, 16" x 11".

projected self-image and cultural norms going back to Romanticism and mid/late-nineteenth century culture.[47]

Fig.45 then reflects Hilton's bohemian self-image and also suggests some journey through life with his partner, the horse turning the cart towards a descending sun. Indexed to this series of images, ill.18 with its stationary cart and heap of autumnal leaves signifies the end of life's journey. The cart's

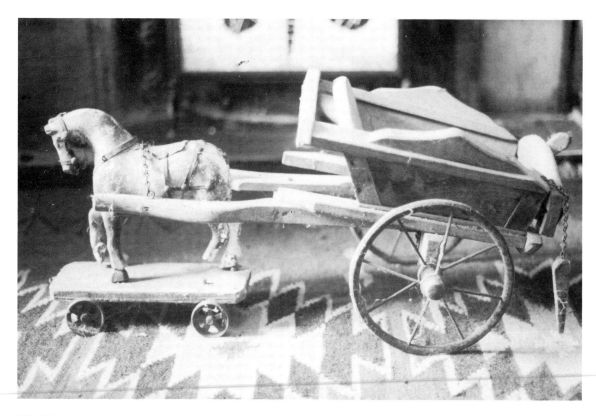

Fig.43 Hilton's childhood horse-
and-cart. Cart 11" x 25", horse
12" x 11".

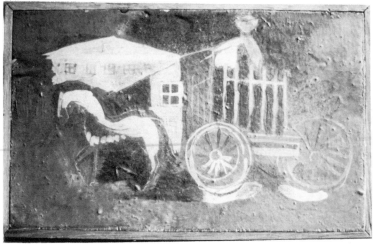

Fig.44 Late 1940s, oil on wood,
6" x 10".

shafts become ladders of spiritual ascent for someone physically immobilized.

Our ability to access the late work for discursive meaning depends then not solely on the cultural coding of painterly sign and the developing system of mark/shape/image within the gouaches but also on the development of images across his whole oeuvre. Images signify within such intermittent yet extended series by difference and across series by association. Horse-and-cart thus connects with other images of journeying using trains, cars and boats. Of course, the connection of the boat and spiritual voyaging goes back centuries and is certainly

found in the Egyptians. Literary boats range from the *Odyssey* to a host of nineteenth century exemplars. However, like the image of the horse's vital energy, the image of the lonely boat at sea is quintessentially Romantic in its lineage, reminding one of Hilton's description of the spectator's need to trust to his early abstracts 'like you would an open boat upon a dark and stormy sea'.[48] It is the unsettled relationship between the individual and a universe in which intrinsic value can no longer be found which is the problem first confronted in the eighteenth century and which works itself out through to Existentialism. As an existential abstrac-

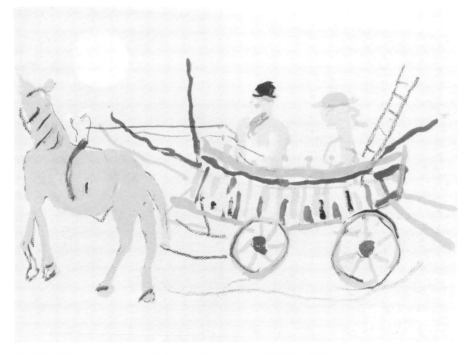

Fig.45 1974, gouache and charcoal on paper, 13³/₄ " x 19".

tionist Hilton had described the artist as trying to construct with his formal means 'a barque capable of carrying not only himself to some further shore, but with the aid of others a whole flotilla which may be seen eventually as having been carrying humanity forward to their unknown destination'.[49]

If the older Hilton might have found that overblown youthful rhetoric, he certainly still associated the marine journey with spiritual voyage. His statement 'And let there be no mourning at the bar, when I set out to sea'[50] helps clarify the suggestiveness of fig.46, with a solitary figure in a vessel accompanied by a black dog (possibly suggesting imagistic companion dogs or mythic guardian dogs, or even the dog associated with the temperament of Melancholy). The image evokes representations of journeys of death in various cultures, while the figure itself already suggests a sculpted commemorative bust.

Hilton's interest in the imagery of boats goes back to his childhood[51] and his mature oils had certainly invited associations with boat-imagery to some degree. Images of boats in his late work were numerous.[52] One splendid 1973 gouache (ill.19) profiles a simple vessel with thickened erect mast pointing to a favourite motif of fruity or prickly sun. The boat's shape is rhymed in the patch of blue sea which carries it. This profile is combined with a vessel's plan, complete with blue strokes between the oars and overtopped by a pair of blue 'knees'. The decorative exuberance of the oval plan takes on sexual overtones. A lone yellow silhouette gazes at this area of delight located between calm cool azure.

Fig.46 1974, gouache and charcoal on paper, 20½ " x 15½ ".

Imagery and Poetry

Another source for Hilton's imagery of the sea and boats is poetry.[53] We saw earlier Hilton's interest in poetic imagery and actual attempts at writing poetry in the late 1940s (fig.33). In 1956 he met the Scottish poet Sydney Graham in Cornwall and they became close over the next decade. Graham had emerged as one of the Neo-Romantic group of poets around wartime Fitzrovia which looked to Dylan Thomas as exemplar and his early poetry is highly incantatory, woven around a music of words, teeming with sensuous and dramatic images, becoming more direct and individual as time went on. When Hilton and Graham met, Graham had just published *The Night Fishing* (1955) based on his experience of fishing in Scotland and Cornwall.[54]

The title poem of his 1955 collection *The Night Fishing* reflects on his birth, the relation between home and the voyage, his existential situation and poetic purpose in the context of a night's fishing trip:

I, in Time's grace, the grace of change, sail surely
Moved off the land and the skilled keel sails
The darkness burning under where I go...
After that, the continual other offer,
Intellect sung in a garment of innocence...
The voyage sails you no farther than your own.

And on its wrought epitaph fathers itself
The sea as metaphor of the sea...
.......Each word is but a longing
Set out to break from a difficult home. Yet in its meaning I am.

Here the account of an actual expedition uses as metaphor life's journeying ('the sea as metaphor of the sea'). The jetties of the quay release the boat to the open sea as the young poet was 'waved from home to out'.

There was frequent communal poetry-writing involving Graham and other artists in Penwith pub-gatherings and a batch of humorous punning letter-poems from Graham to Hilton survive, as well as Graham prose-letters with painted images.[55] Graham encouraged Hilton in making his images 'result in some disturbances which, at least to the painter, are a hieroglyph of a world with values we have never experienced before',[56] a position deriving ultimately from Symbolist aesthetics.

The sea voyage and 'drunken boat' were key images of early modern French poetry.[57] Baudelaire's 'Le Voyage' talks about real travellers as driven by unknown restless desires and hopes but finding only their own image everywhere, ending with boredom and bitterness. Both voyaging and staying at home are presented as tricks to deceive time, which elsewhere the poet tells us can only be defeated by intoxication of some sort.

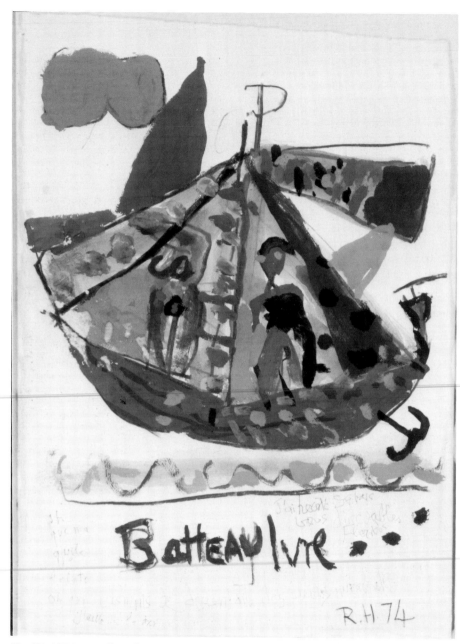

Fig.47 1974, pencil and gouache on paper, 23¼" x 17".

Mallarmé's 'Brise Marine' recognises the possibility of the dashing of hopes consequent on travel but focuses on the heart's dream of escape. The Symbolist figure who clearly meant most to Hilton in his later years, however, was Rimbaud, for whom the sea-voyage is all mythic structure (he drifts through 'le Poème de la Mer').

Hilton inscribed one 1974 gouache (fig.47) depicting a male and naked female figure in a sort of sheltered boat on snake-like waves "batteau [sic] ivre", the title of a famous Rimbaud poem. He adds below the gouache the following lines:

> Comme je descendais des Fleuves impassibles...
> J'ai heurté, savez-vous, d'incroyables Florides...
> O que ma quille éclate! O que j'aille à la mer!

Where for Baudelaire the decision to travel or remain stationary was an existential choice, Rimbaud's image is one of uncontrollable drifting down dull rivers to the exhilarating freedom of the ocean. All ties and the world of commerce are left behind and Rimbaud lets go and abandons himself to a greater force. During this ecstatic drifting the poet jostles against 'unbelievable Floridas' with wonderful intoxicating sights, though this intensity of passion also produces sadness and tears. He cannot defeat the world of law and commerce, and aspires to return to being a child launching a paper boat on a pond. Before admitting defeat, the poet states that he has had enough and wants his keel to break so that he will sink into the sea and meet death. Instead of outer action, the events are dream-like, with sea and sky often seeming to fuse. There is a sensual identification between body and boat in this poem that would have appealed to Hilton, as well as a fluidity of images and suggestive overtones. One could cross-refer from Hilton's gouache to 'les rousseurs amères de l'amour', 'les serpents géants', or the proud pennants of other ships going by, except that the use of vibrant scattered colours, wavy bands and celebratory pennants is found throughout the late gouaches as part of Hilton's own imagistic system.

Symbolism has always been recognised as the start of literary modernism but, perhaps because of the 'anti-literary' rhetoric of early twentieth century art theory, its relevance in the history of modern art has not been perceived clearly, despite the fact that typical early modernists such as Matisse and Sonia Delaunay 'illustrated' Mallarmé and Rimbaud respectively. The Symbolist image is special and not easy. It generates an aura of suggestive meaning around it and cannot be 'cracked' fully by any decoding. The commonality of the term 'image' in talking about modern painting and assumptions about 'openness' of meaning indicate how important Symbolism was in first articulating certain standard features of modern culture.

Suggestive power is given to the image, but problems of determinate meaning remain. This is the condition of the modernist image. The 'forest of signs' in fig.48 includes circle, cross, arrow and what could be a squiggle only or numeral three. Earth colour unites rear sail and hull, while blue is transposed onto elements supporting a white foc'sle where skull-and-crossbones becomes balls and cross (suggesting eros and thanatos?). Alternatively the circles could be read as the eyes of a face taking in the front of the ship, with the blue porthole as mouth. The sail marking doubles as arrow pointing to a circle, which could be read as the eye-socket of a skull comprising the rear half of the ship, the gap between sail and hull suggesting a row of 'teeth'. On the blank whiteness of the paper sheet, marks, signs and elemental colours are laid out to proliferate meanings yet withhold the sense of a full purchase on the image by the spectator.

We can also learn much by studying the context of those lines of Rimbaud's which Hilton is known to have quoted. In one of the *Night Letters* (p.184), Hilton quotes from Rimbaud's 'Chanson de la plus haute tour':

> J'ai tant fait patience
> Qu'à jamais j'oublie;
> Craintes et souffrances
> Aux cieux sont parties.

This part of *Une Saison en Enfer* comes as the poet is rejecting his earlier 'delirious' poetry and saying farewell to the world in more traditional ballad-type poems. He seems to be addressing an idle youth or else reflecting on his own past, an incredibly short past as was observed by Hilton in the note quoting the lines from Rimbaud, and Hilton himself also regretted the years of his early manhood, describing them back in 1942 as 'years of steadily increasing egocentrism'.[58] Rimbaud seems to be criticising his own 'délicatesse' and yearning for a season of full-blooded love. As the situation stands, life might slip away without the promise of higher joys. The protagonist has been so 'patient' that now he has an unhealthy thirst. His heart is compared to a neglected meadow, and the whole poem focuses on regret.

The lines quoted by Hilton are preceded by a celebration of drinking, which then may have connected in his mind with Rimbaud's reference to being 'enslaved by everything' and to the role of excessive drinking in the break-up with Graham. The Rimbaud lines are followed in Hilton's letter by a lamentation of his own lonely misery if friends like Graham die before him. Perhaps there is also regret at the ending of his relationship with Graham, who had been able to articulate his strong love for Hilton, which one suspects Hilton had not been able to do directly.

In the March 1974 Townsend letter, Hilton quotes from an untitled poem which appears in *Illuminations* and, in a different form but without the lines quoted by Hilton, in *Une Saison en Enfer*. Its initial title might have

been 'The Seasons', a favourite Rimbaud term for a phase of one's life and one which Hilton also deployed with the same meaning in a note on the phases of his life around 1960/1. This poem uses the image of 'château' for the soul but rejects the notion of perfection and celebrates the crow of the Gallic cock. (Hilton too used the cock image as sexual projection) Rimbaud has learned the magic of bliss but now desire has caught his heart and soul and scatters his efforts. His words are blown away, and he wonders what they mean any more.

> Que comprendre à ma parole?
> Il fait qu'elle fuie et vole!

Its theme seems to be the happiness resulting from an abandonment to sensual joy. Rimbaud's preoccupation with joy is well expressed in 'Alchimie du verbe': 'le bonheur était ma fatalité, mon remords, mon vers.' This bliss produces a sense of the dispersal of artistic means. This could be read to mean moving to a state which cannot be caught by art, or that artistic means need to become so swift in their flight that they might catch desire 'on the wing' as it were.

Hilton clearly responded to Rimbaud's resistance to social norms and his desire to transform artistic means into an instrument capable of containing the rhythms of the universe. There is a similar grand ambition on Hilton's part and attempt to extend one's means to capture boundless desires. The swift succession of sensual concrete images in Rimbaud's poetry is designed to liberate one from normal thought patterns, though the irony is that Rimbaud's intended 'derangement of the senses' in 'Bateau Ivre' is brilliantly achieved through conscious aesthetic organization, as I have argued is the case in Hilton's 'disorder'. Rimbaud ran through a remarkable trajectory and rejected his belief in the 'alchemy of the word' deriving from a disordering of the mind at an early point in his life. For Hilton, this example reminded one of possibilities of artistic practice though perhaps he realized the need to keep his feet on the ground in terms of observing the world about him, and keeping a clear articulation of images.[59]

Without wanting to make some exceptional claims in this regard for Hilton, my aim here has been to indicate his intellectual bearings and especially his affiliation with French early modern culture as well as to indicate the depth of his involvement with imagery by reference to his interest in poetry. 'Freshness' and 'naivety' of vision were key values in mid-nineteenth century French culture. Baudelaire praises his paradigmatic 'painter of modern life' for being a 'child-man', 'a man possessing at every moment the genius of childhood [wherein] no aspect of life has become stalely familiar'. Baudelaire's notion of genius involved the idea that it was 'simply childhood rediscovered by an act of will'. Several Rimbaud poems such as 'Enfance' and 'Jeunesse' are

evocations of childhood vision, but more importantly Rimbaud too saw the development of the visionary artist as involving a regression in time to the point where he would aim to recapture childhood vision and especially its oneness with the universe. Such a powerful cultural idea needs close examination on various levels.

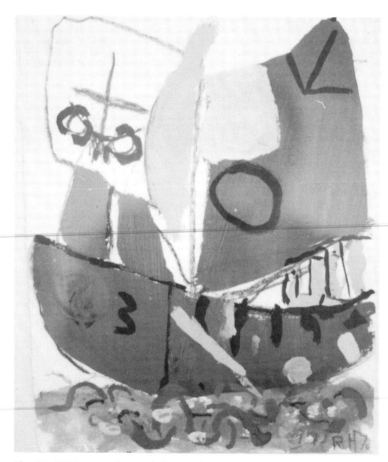

Fig.48 1974, gouache and charcoal on paper, 12" x 9½" – 10".

'Childhood Rediscovered by an Act of Will'

The modern notion of 'childhood' as a phase of life distinguishable from adulthood (or even 'youth') began to be put together from the seventeenth century onwards and by the nineteenth century 'childhood' had become a privileged age.[60] Clearly one way of reading this development is in terms of the rise of 'bourgeois individualism'. Individuals are respected as 'proprietors of their own capacities',[61] so that children are respected as autonomous beings and adults are fascinated from an ontogenetic viewpoint in reviewing their own 'emergence'. Ideology determines a 'conflict' between self-determination and social formation, (human) nature and culture.

Going back to the eighteenth century, we find Julie in Rousseau's *La Nouvelle Hëloise* (1761) stating that 'everything consists in not spoiling the man of nature in appropriating him to society'. Early education is presented as designed to allow the child's 'nature' to develop, and avoiding appeal to reason since nature wishes 'that children be children before being men'. Childhood 'has ways of seeing, thinking and feeling which are its own.' In *Emile*, Rousseau recognised that he had a problem in implying that early education did not denature (or, as we might say, socialize) the child. The opposition between nature and culture which we find articulated in Rousseau is ultimately an ideological contradiction of liberal-bourgeois individualism, wherein self-possession denies social and historical formation.

Passing down into modern art we find an ethic of sloughing off 'culture' in order to return to 'nature'. The position of 'unlearning' culture in order to return to some aboriginal 'nature' clearly raises problems about whether one can come to know less than one actually does through some process of giving up knowing or understanding. How could one continue to be involved in cultural production and yet also give up culture for nature, without the only logical solution of ceasing to be involved in cultural production? Or else, if we connected 'nature' here with the cult of the child, it would mean giving up an art-producing role and allowing drawings to assume the role (e.g. of throw-away play-items) which they do for the child. Hilton's late work would not survive if he had really behaved as a child in relation to his work. In other words, he was playing at being playful. Hilton may have adopted an anti-precious throw-away attitude to his gouaches, as we shall see, but this was a strategy for his own artistic 'rejuvenation' in the end.

As well as considering philosophical attitudes to nature and culture going back to Romanticism, we need also to consider more specifically changing readings of children's drawings and modern artists' handling of such material in order to understand fully

Hilton's use of child-art. Going back to the Romantic period, Victor Hugo was fascinated by his children's drawings and how they related to his own drawing (fig.49). In 1887 we find an art historian, Corrado Ricci, writing a study of *L'Arte dei Bambini*, an interest which spread in the 1890s. In discussions of children's drawings from the viewpoint of psychology of perception, philosophical tradition produced a discourse revolving around polarities of mental idea or observation of

Fig.49 Drawings by (or after?) those of Victor Hugo's children in one of his albums, c.1830 Bibliothèque Nationale, Paris.

nature, so that James Sully's 1896 *Studies of Childhood* talked about the 'symbolist' rather than 'naturalist' vision of the 'child-artist'. By 1917, Roger Fry was celebrating children's drawings where they were not the product of education, although the first show he praised consisted of work by children of artists and the second of work by children taught by Marion Richardson.[62] Since then it has been shown how culturally contingent children's drawings can be.[63] However, generally in this century children's drawings have been praised for a varied series of automatically approved qualities from playfulness, immediacy, and simplicity to 'vision and design'.

In aspiring to these qualities, modern artists have regularly appropriated the image of the 'child-artist'. Courbet identified with the notion that the child's vision was a model for the modern artist when he included a child beside him gazing into his landscape and another drawing on the floor in *The Artist's Studio* (1854-55). Courbet, like Monet, Cézanne and countless other well-educated artists, played down their formation. If 'freshness of vision' involved an appeal to child-like 'naivety' for realists, Symbolists employed in a critically positive direction the neutral terminology of 'symbolic vision' developed by psychologists. 'Der Blaue Reiter' incorporated an admiration for child-art into its primitivism, and for Kandinsky children responded to 'the inner sound' of things in a way which became

more difficult later. Brancusi and Matisse claimed child-like vision as central to their artistic life. In a 1953 essay, Matisse claimed that the artist 'has to look at life as he did when he was a child' if he intended to be original, while Picasso saw himself late on as trying all his life to get to the point of painting like a child.

However when we get down to specifics and look at how modern artists compare to 'child-artists', we are confronted with a more complicated picture. Elementary figure-signs or even simple ovals on legs are sometimes used by Miro from very early stages of children's drawings, but these become part of his own suggestive and rhyming sign-system with an imaginative range quite specific to adulthood. Miro's ambiguous relation to child-art is important here because there is evidence that his *Celestial Starfish* reproduced on the back cover of *Studio International* (December 1969) was studied closely by Hilton at the start of his late gouaches.[64] Klee, who had interested Hilton in the late 1940s,[65] often used the style of children's drawings directly, but again the point is that he felt free to draw on different stages of cognitive development as embodied in drawings (ones later than Miro drew on) and he combined these with a modernist colour-architecture and adult irony. Although Klee had stated in 1912 that 'the primordial origins of art are to be found at home in the nursery', by 1930 he was warning: 'Don't relate my work to those of children. They are

worlds apart'.[66] Once again, Dubuffet's style of drawing may refer to young adolescent drawing, but the sexual urgency and urban imagery, the imagistic emphasis and deliberate materiality of the 'coarse' image reflect the intentionality of a mature artist.

On one level, the appearance of child-art serves to trigger certain spectator responses. The work is produced in discourse as 'charming', 'fresh', 'immediate', 'uninhibited', or 'playfully unconcerned' with the permanence, status and cultural pretensions of cultural artefact. On another level, the illusion is clear to critical commentators.[67] Hilton makes the difference clear himself:

> One has to face the eternal problem about children's art. It is often charming and you can borrow from it. The difference is, I think, that children are essentially realists, whereas a mature painter is not.[68]

If we were to ask why Hilton adopted this 'look' or even raised the point here if it was a problem, then our answer would have to be that he wanted to enrich the artistic 'text'. In his statement, it allows him a startling paradox, given that adults are usually seen as realistic in outlook. His apparent paradox must be read within a cultural tradition of praising the imaginativeness of child-art.

Hilton is cleverly drawing attention away from imagery to the status of the image. Piaget refers to the first four years of a child's

development as characterised by 'logical and ontological egocentricity'[69] in the sense that the child constructs its own reality. That is the sense in which Hilton uses the term 'realist' here. A sense of distinction between self and external world, between the activity of drawing and what is being drawn, marks the start of more mature vision. A mature artist is aware of making an image or illusion which does not command or constitute reality (although some modernists have made such claims), and is aware of making a 'dream-work'.

We saw how Hilton in the 1930s shared in the late Ecole de Paris's interest in the charm of faux-naiveté. The cult of child-art continued in French and British visual art culture after the war. Hilton explicitly refers to his desire to appropriate the look of 'child-art' mess in a published statement in 1961,[70] and his first explicitly child-like drawings date from the early 1960s.[71] Hilton had two more children by his second wife who in 1973 were aged eight and twelve. Presumably he was fascinated by watching them drawing, and he also had a selection of his own drawing books with him in the cottage. He wrote notes in Album C from c.1923 and dated other ones at this time.[72] In other words, at some stage(s), Hilton made a deliberate point of perusing his earlier drawings, going right back to his youth. Having kept his childhood drawing books, he was now (to use Baudelaire's phrase) wilfully recapturing his childhood.

Hilton did not revert to a particular moment of child-like vision and drawing but synthesised various aspects from different stages of childhood drawing development. In stressing the appropriative and synthetic nature of his 'recapturing of childhood', it is my aim to stress the conscious artifice involved in creating an illusion of 'unconcerned spontaneity'.

We have seen how the underlayer of drawing in the gouaches connotes alteration (pentimenti). A conscious manipulation of signs of change to the image is built in at the start in terms of his artistic strategy, more so than his 1974 Studio International statement about 'accepting' mistakes makes clear. Here he refers to food dropping on his paper and his needing to 'tidy up the mess' with 'a few simple strokes'. This image of the artist magically transforming chaos into aesthetic order is powerfully attractive but should be taken only metaphorically, since food remains are not a substantial part of his late facture! Any external drippings which remain are consciously left to add to the texture of 'scruffiness', and we certainly have a testimony that 'he very consciously made [his late gouaches] spontaneous' by 'spitting at them'.[73]

Sometimes the underdrawing is scribbled, though it is usually more determinate. Sometimes the motor-action of making marks seems relished and a stage of decorative scribble in children's art is indexed, although if we look at ill.6 in this light, there

is a suggestion of imagery (ladder, tree, human presences), spatial/compositional flow and colour-linkage quite foreign to the production, for example, of child finger-painting. Hilton aims to invest autonomous marks (such as the blue circle to which lines are added bottom left) with a suggestion of human presence, whereas the child believes that a circle and vertical lines ARE that human reality and not traces of it.

There is some reference, then, to features of children's drawing up to the age of four or five. Efforts at about that latter age to suggest a wider environment result in a sense of revolving space, which we might see being utilized in ills.12 and 13. Space is represented as revolving around the body for the child of this age and what is important looms largest. Although Freud saw the mature artist as remaining to some extent in this narcissistic phase, if we look at Hilton's vision, there is often a play with scale which places human beings or animals within the frame of the natural world so as to demote humankind from the centre of the universe in a manner quite impossible to compare with the literally egocentric outlook of the child. This sense, of course, is also combined with that of how reality relates to the immobilized and dying artist.

While in some cases Hilton's space is as fluid as that in children's drawings from about ages 4-7, his main reference is to the mode of vision of the following three years, when figurative schema are redeployed

unconsciously, results are still decorative, and space is still subjective, mixing plan and elevation, as Hilton does perhaps in fig.13 and on the title page. Hilton's images (e.g.ills.14,18, fig.23) adopt the profile representation along a sort of base-line which appears in these childhood years. Those adults who have internalised elements of modernist discourse tend to find that their cherished qualities of 'free expression' in image-making and handling of materials begin disappearing over subsequent years, as different cognitive interests develop as the youngster begins to recognise the separate reality of the world and to become concerned about relating to peers and a wider society.

Although I have argued for Hilton's reflection back over his own development, I have to recognise that the early drawing books to which he had access came from this later teen-age (figs.11-12), whereas the phase to which he mainly referred in his own stylistic conventions was that of 7-9 years, the last 'privileged' years for modernist taste and corresponding to the age of his youngest son. However, reference to qualities from this phase of drawing development is combined, both within the same work and from one work to another, with the appearance of earlier phases of development.

I have not searched for traces of an original artistic 'essence' in Hilton's earliest work, but have treated similarities between his later work and 'child-art' as deliberately willed.

'Childhood Rediscovered by an Act of Will'

Such a decision to forge a similarity has been located in the context of cultural valuation of the 'child-like' and 'naive' which delivered a cultural value of 'simplicity' and 'freshness'. To work against that critical circularity, the complexity and wrought illusion of Hilton's late work has been emphasised. Rather than 'naiveté' being a condition of the artist's originating vision, it is the artist's knowing aim that the spectator receive the work (at least initially) as 'child-like'. As we saw earlier, it is the mediated form of the work which ensures that it ends up being perceived as 'immediate' in a far from immediate aesthetic experience.

Deconstructing Art into Life: Conflicts and Contradictions

It may well be that today we have problems with the commercial attractiveness of the child-like look in a way that was not true for earlier modern art. It is not reference to child-art within a sophisticated aesthetic which commends Hilton to our attention in terms of critical edge, but his limited resistance to the role of art as consumer good and his sense of the power of art to act, in Adorno's words, as plenipotentiary 'of things beyond the mutilating sway of exchange, profit and false human needs'.[74] We need to remember that his late artistic behaviour involved a tendency to break down the boundaries between category and status of activity and to cut against hierarchy of cultural value-systems. For example, Hilton may be writing a note, sending a greeting, or doing his art-work. It is artificial to make clear distinctions between letter, drawing and painting. His gouaches also involve a total giving up of oil-painting for a medium without cultural kudos, while the notion of the rare master-piece is challenged by his strategy of high daily productivity (obscured *de facto* by any selection of illustrations in book/catalogue form, a misrepresentation which the text must work against).

Firstly let us remind ourselves about how Hilton tried to resist his art becoming fetishised as commodity. He drew in person-al correspondence, so that his graphic activi-ty was not confined to his 'artworks'. Notes which he left his wife included drawings and thoughts.[75] Sometimes a note can become transformed into an artwork. In ill.21, the word 'fuck' in the inscription 'Fuck you where's my suger [sic]' has been altered to 'For you', suggesting rapid alternation of feeling. An irritable message to his wife is flipped into a literally delightful painterly gift as recompense for bad temper.

Works released to the outside world included writing, sometimes relating the sheet to functions other than that of art-work. Hilton comments on the materials which he is using in one Antibes gouache (fig.50) as if to indicate what new materials need to be bought, while decorating the sheet with palm tree and pattern. Plans redesigning the cottage become artworks

Fig.50 Inscr. "Antibes VII 74 RH" etc, pencil, felt tip and gouache, 13" x 16".

(figs.8-9). A 1974 gouache owned by Manchester Art Gallery has a shopping list deleted by overscribbling in its bottom left. To take up the conundrum of whether Nietzsche's laundry lists should be included in the 'complete writings', where does one draw the distinction between a note with a drawing, an illustrated letter, and an artwork with words included? Hilton is deliberately playing with boundaries, yet the limits of such cultural resistance are demonstrated by the potential of the art market to ignore differences of status (since letters are marketable ultimately).

Let us pursue the contradictions evident in Hilton's practice without criticising him for contradictions produced by social reality. Indeed it is the visibility of these contradictions which tells us that there is something more interesting going on in Hilton's career than in that of other artists of his generation. In his March 1974 letter to William Townsend, in order to posit art as spiritual entity independent of material production ('in the mind'), Hilton suggests that 'you could go in the back yard and scrape up some mud and put it on some board' in order to make art. Actually the point he is making is about cost and not materiality.

In this letter he emphasises the cheapness of gouache, and in a letter to Peter Barton from 26/3/73 he links this with 'a throwaway element which I like', although in the next sentence we learn that he has 'taken to signing all my things even before they are finished'. In a note to his wife, he alternates in his view over the poverty or quality of materials. 'I have to have materials, not just children's stuff. One has to be fair to one's clients. Balls. I am on the last run. It doesn't matter what materials I use. But as you know, the more you pay, the better quality you get.'[76] His wife even recalls him ringing up the manufacturers of his gouaches to check that they would not fade over time.[77] Poverty of materials was much in the avant-garde air at that time, polemicised into a movement by Germano Celant. The fetishizing of material properties in 'arte povera' removed its artistic 'space', whereas the element of 'illusion' maintains the potential for 'alternative' values. Poverty of materials was certainly part of the artistic illusion in Hilton's late gouaches.

'Openness' to living experience is another fundamental aspect of their illusionism. A new point to consider in this context is Hilton's initial ideas for framing these gouaches. In the Night Letters, Hilton reiterates a modernist theme when he proclaims that framing ruins paintings.[78] Within the ideology of modernist painting, once the qualities of the medium had been hypostatized, physicality asserted a 'free' presence which was confined by framing, even though the market saw to it that investments were protected in a variety of ways. The modern art market has regularly protected works on paper, but it is interesting to see how John Miller recounts what was going

through Hilton's mind concerning presentation of his gouaches for the 1973 Orion Gallery exhibition:

> He didn't want them to become objects of art...If you think of his *Night Letters* along with his drawings, he had allowed the gouaches to become somewhere near letters at times... What he wanted was [for] the gouache to simply float on the wall. So we experimented with the idea of getting two sheets of perspex and simply enclosing this thing in them...He wanted whatever it was against to come through the perspex. It didn't work. It looked too contrived and in the end we floated them onto a backboard and then we put a mount so that there was plenty of space around the drawing in a rather conventional way, with a simple frame around it.[79]

Hilton's statement in a letter that he hated 'that unknowing eyes should peer at my work', resulting in pressure to make that work 'easy for unknowing eyes and therefore second-rate'[80] typifies the artistic model of early modernism resisting easy 'commerce' with the world. Yet the *Night Letters* indicate his desire to exhibit his late gouaches. Sometimes it did not matter where,[81] at other times he clearly had his sights set on London, and his own promotional activities via the Orion Gallery and then the Artists'

Market in London clearly worked in raising his prices and getting his dealer interested again. This takes us into all the ideological contradictions of the notion of 'self-control' central to the ethics of modern art. The American painters of the same generation also hated their work being seen by the public and needed that exposure, were represented by galleries and wanted to feel control over their careers. The extreme end-results were paranoia (Still) or suicide (Rothko). Somewhere in between the two extremes, careers flourished.

Jeremy Le Grice encapsulates how Hilton flourished uncomfortably in that gap:

> Roger saw himself as an outsider...and when he did get his CBE [in 1968] he was the next day in St. Just bus station trying to give it away to very perplexed St.Justers saying 'I can't bear this f....medal' and lying under the bus saying 'I'm doomed. I've accepted this thing. It's the kiss of death.' Although he was very impressed with people who could get on well in Establishment terms, at bottom he despised it too. But then also he was always rather good at keeping in with Alan Bowness and people like that, so it's very complicated. But his anarchism and his vitality as an artist were synonymous in his own eyes.[82]

Individual self-determination lies at the

Deconstructing Art into Life: Conflicts and Contradictions

centre of that early modern outlook which we know to be quite consonant with bourgeois radicalism and anarchism from Courbet onwards. In this world-view, an artist is 'revolutionary...[but] probably doesn't even vote', as Hilton wrote to Townsend. The revolution is 'in his own domain', involving his own 'breaking out' from 'old moulds'. Such an artist survives on the operation of the market but feels some basic antagonism between its operation and the pursuit of his own anarchic ends. The ultimate validation of this stance of ethical probity was in 'failure'. The cultural model typified by Balzac's *Le Chef d'Oeuvre Inconnu* runs down through nineteenth century French culture. Degas' 'failure' at sculpture and his ultimate 'triumph' is simply one of the clearest instances of this pattern. Even (relative) failure, if it guarantees an authenticity of position, can involve some self-determination of a 'last laugh'. In this regard, what Jeremy Le Grice speculates concerning Hilton's late production takes on a larger dimension:

> Then he was saying very openly that he had left Rose and the children with nothing and I think that at one level he did [the late gouaches] quite cleverly

(very cleverly, in fact) as a sort of pension for them. I think that he would have said something to make one think that...[although] he knew they were pretty good.[83]

Bob Dylan's 'there's no success like failure and failure's no success at all' created a simple mnemonic for a complex field of ideological tensions which marked early modern culture and has been reorganised ideologically as the 'triumph of modern art'. Its relevance to the grounding of Hilton's reputation and its effect over the past two decades is clear. It was quite typical with the cultural figures with whom Hilton identified that their efforts were made public or esteemed at some later point in time. For example, it was others who had published Rimbaud's central efforts long after their being put on one side. Indeed, I might reflect on the typicality of my own situation and that of future commentators in presenting his scattered oeuvre, including a vast late work which is still largely unknown and which this study has only been able to sample. Any such recovery and reconstitution of Hilton's work inevitably becomes part of the re-presentation of his 'failure' as 'success'.

1. See, for example, J.Lewinski, *Portrait of the Artist: 25 Years of British Art,* Manchester , 1987, and M.Canney, intro., *Roger Hilton: Night Letters and Selected Drawings,* Penzance, 1980. Further photographs by Ander Gunn are in the archives of the National Portrait Gallery. For yet another photographer who documented Hilton in his last days, see n.43.

2. Terry Frost interviewed by John Davie and Jill Neville, Jan.1992.

3. Letter to parents, 24/5/42 and memoir by Ruth Hilton, excerpted in A.Lewis, *Roger Hilton: The Early Years,* Leicester Polytechnic Gallery, 1984, p.22.

4. *Lewis* (1984), p.24.

5. Letter from Rose Hilton to Michael Canney, 23/4/73.

6. Letter from Michael Canney to present writer, June 1990.

7. Interview with John Miller, 18/4/92.

8. 'Letter to Peter Townsend', *Studio International*, March 1974. In a letter to Peter Barton, 26/3/73, Hilton mentions 'turning out 2 or 3 gouaches a day'.

9. Reply to questionnaire, 1/89. In response to the suggestion of an average output of two per week instead of per day, Rose Hilton accepted this as 'fair' in the same letter. In a subsequent reply (5/10/92) to a questionnaire, she suggested that the number of gouaches should be seen as around 400-450. What it meant for Hilton to focus on his artistic 'fertility' is clearly a different issue from the literal one of numbers of pictures produced.

10. Listed consignments of gouaches begin on 29/8/73 (3) and 1-2/4/74 (8). The biggest consignments are on 13/5/74 (21), 29/8/74 (27/28), and 19/10/74 (26). Only one gouache is included in the December 1974 consignments, while the last on 19/2/75 included 23.

We might be excused for thinking that this gives us a clear picture of Hilton's productivity level and confirms Rose Hilton's rough figure except for a higher level of production over the spring and early autumn 1974. Unfortunately work was not sent in such neat chronological packages. Despite a January 1974 consignment, the May consignment included 15 1972-3 works. Two 1973 works were included in the August 1974 consignment and ten in the October one. Nearly half of the final consignment carries a recorded dating of 1974, one with the specific date of 21/9/74, since which date three other consignments had been made.

11. *Night Letters* (1980), p.68. The book is unpaginated. For convenience, page numbering is applied starting from the acknowledgements as p.1.

12. Rose Hilton, letter 12/77, *Tate Gallery 1976-8: Illustrated Catalogue of Acquisitions,* London, 1979, p.91.

13. Picasso's late work was just beginning to be known following the 1970 Avignon show. Although we cannot be certain just how aware of it Hilton was, he does seem to mention it in a newspaper interview with Frank Wintle not long before he died and one would expect him at least to have picked up the general drift of Picasso's late development (if only from the media or conversation). Therefore it may have provided some role-model at however great a distance, although it was not as esteemed as it became over the following two decades. Douglas Cooper, for example, criticised the 1970 exhibition as 'nothing but the incoherent scribblings of a frenetic old man in the antechamber of death'.

14. As regards inscriptions on the late gouaches, a local review of the Orion Gallery exhibition in June 1973 (*Peninsular West,* 16/6/73) illustrat-

ed the image of a prehistoric beast with an inscription 'Hilton 11 3 73'. Other works from 1973 carry a full-name signature (eg. G.Moppett, *Roger Hilton: Works on Paper*, Mendel Art Gallery Dec.1981-Jan.1982, cat.15). Very occasionally a more specific date appears (e.g.Waddington Gallery, *Roger Hilton: Works on Paper*, Oct.-Nov.1974, cat.25,31,32, Austin/Desmond Gallery, *Aspects of Modern British Art VII,* May-June 1989, cat.21, Graves Art Gallery, Sheffield, April-May 1980, *Roger Hilton: Last Paintings,* cat.41, Mendel Art Gallery, 1982, cat.15, 22). This is particularly the case in February 1975, as discussed in the text, and some works done in Antibes are so inscribed. However, by far the bulk of the late gouaches carry a standard inscription of initials and two-figure indication of year.

15. Interview with John Miller, 18/4/92.

16. Watkiss surreptitiously taped his November 24 1973 interview by helping him tape the statement which Hilton had written for *Studio International* and by pretending to have turned off the tape recorder at the end of this. At a certain point during the conversation, Hilton hinted that he realized that he was being taped but continued anyway.

17. Letter from Alan Green, 13/8/92.

18. Ibid.

19. This comparison does not work exactly of course because the older artist in *The Ebony Tower* is dismissive of modern art entirely.

20. Another idealised image of the studio-home appears (alongside their Cornish neighbours, the Ladners) in *Night Letters* (1980), p.85. Two other extant images developed from the plan for a playroom for the children and reflect his impatience with the liveliness of his young boys (inscr.'Planned building for children who will be chained', 1973, gouache and charcoal, 15 x 22", Martin and K.Brunt, and inscr.'The Two Boys Chained Up', 1973, gouache and charcoal, 15 x 22", Rose Hilton).

21. Rose Hilton letter to present writer, 6/11/89 (questionnaire 1/89).

22. e.g. *Roger Hilton: Works on Paper*, Waddington Galleries, Oct.-Nov.1974, cat.31-32.

23. Interview with Karl Weschke, 17/4/92.

24. Against the top paragraph, p.47, of his own copy of N.Kessel and H.Walton, *Alcoholism* (Harmondsworth, 1965), Rose Hilton coll., discussing the number of bottles of spirit drunk in a year on average, Hilton wrote 'I consume 300'.

25. *Night Letters* (1980), p.192.

26. Interview with Rose Hilton, 16/4/92.

27. e.g. *Night Letters* (1980), p.184.

28. This description appears in the chronology of his retrospective exhibition *Roger Hilton: Paintings* 1953-1957, I.C.A., London, Feb.-March 1958, and may derive ultimately from Hilton.

29. Many creatures from spiders to crocodiles and prehistoric animals appear in spotted guise, again emphasising the element of projection in Hilton's image-making e.g. respectively *Graves* (1980) cats.9 and 4, and 16 x 13½", Feb.1975, Rose Hilton coll.

30. For example, black occupies the top half of the pictorial field in two gouaches in the collections of Michael Canney (16½ x 14", 1974) and Sheffield City Art Galleries (23 x 13", 1974). The simple 'presences' imply male and female partner through respectively the presence of a red spot indicating psychological identification or looping breast forms.

31. *Night Letters* (1980), p.186.

32. F.Wintle, 'Ferocious Spirit at Peace with Paint', *Western Morning News*, Plymouth, May 17 1974.

33. e.g. 10½ x 15½", 1973, gouache, Sotheby's, 24/5/90, cat.740, and 11 x 16", gouache, 1973, Sotheby's 7/3/90, cat.426.

34. For example, *October 1961* (oil and charcoal

on canvas, 30 x 36", Lord Gowrie) looks suspiciously as if one could read its three presences in terms of Hilton's new family situation, either himself, his first wife and new partner or his new partner and their child about to be born (with forms that one is tempted to call pregnant). His first son by Rose Phipps was certainly born in the following month.

35. D.Brown, *Roger Hilton: Late Gouaches*, Graves (1980).

36. The information about the sexual liaison comes from Terry Frost (interview 28/7/93). My guess is that this crisis took place in summer 1954, on the basis of Louisa Hilton's diary entry for 1/9/54 stating that Roger and Ruth were 'not getting on well just now' and on the basis of Hilton reporting that his first marriage had proceeded well for the first seven years (interview with Rose Hilton, 16/4/92). One peculiar painting survives in Rose Hilton's collection (10 x 8", OC, ill.A.Lewis, *Roger Hilton and the Culture of Painting,* PhD, University of Manchester, 1995, ill.271) which has a tragic quality that might fit the bill of this first batch of 'therapeutic' semi-figurative work. We know of the production of this body of work from his correspondence a little later with Terry Frost (see *Lewis* 1984, p.61).

37. M.Leja, *Reframing Abstract Expressionism*, London, 1993.

38. Compare p.16 (top), *Roger Hilton 1911-1975*, Gruenebaum Gallery, New York, 1976, with our rear cover image. The most pathetic bird is Mendel Art Gallery (1981), cat.22, dated precisely to the month when confinement in Maudsley psychiatric hospital was in the final throes of discussion.

39. e.g. Sotheby's 19/7/89 cat.487 and Sotheby's 27/6/79 cat.179. In cat. 36, Waddington's, Oct.-Nov.1974, two birds appear larger in relation to a solitary boat and perch on an orbital form around the vessel.

40. In the Cone collection gouache, 14 x 13",

Wadd.B1644, boat forms are contained within the blue 'cliffs' and the bird's arcs acquire two large 'eyes', producing a facing quality which appears in a 1973 charcoal and gouache, 5 ½ x 22", Estate 1277, Wadd.B18825, where the eyes appear within the bird's wings.

41. cat.84, *British Painting 1974*, Hayward Gallery, London.

42. e.g. Ripa, *Iconologia*, 1603, p.479.

43. This bird can be seen in Mayotte Magnus' photograph in Graves Art Gallery (1980) and was exhibited ex-cat in the documentary section of *St. Ives 1939-64* (Tate, 1985).

44. e.g.Jeremy Le Grice (interview 16/4/92) took him some eighteenth century books on birds and animals which Hilton found too 'artistic' already for his use. The book dealer Peter Rainsford has a copy of Buffon's *Plates Illustrative of Natural History Part 4* coloured by Hilton around this time. Harry White (interview 17/4/92) took him a book on dinosaurs and received a watercolour of the same in return.

45. Graves cat.6 is our ill.18. Other horse-and-cart images in this show cat.8, 14, 15 and 23. Other horse-and-cart/carriage images include: inscr.'3 '73', 10¼ x 12", charcoal and gouache, Jeremy Le Grice coll.; inscr.'XII '74', 16 x 12", gouache, 1974, Rod Hill, illd. *Roger Hilton,* Hayward Gallery, 1993, cat.70; 8 x 15⁵/₆", charcoal and gouache, 1974, Wadd.B0914; 1973, 14 x 22", gouache and charcoal, ill. *Roger Hilton: Works on Paper*, Waddington's, Oct.-Nov.1974; 1973, 15¼ x 21½", gouache and charcoal, Queensland Art Gallery, Brisbane; 1973, 14¾ x 22", gouache, B18699, Waddington Gallery; 1973, 15 x 22", gouache, ES1395, Waddington Gallery; 1973, 15⅛ x 22", gouache, ES1476, Waddington Gallery; 1973, 15 x 22", ES1418, Waddington Gallery; conté and pastel, 5¼ x 8¼", ES732, X09233, Waddington Gallery; 8 x 10", conté and watercolour, ES66, Waddington Gallery;

pastel, biro and conté, 8 x 10", ES32, Waddington Gallery; 8 x 5", pastel and conté, ES45, Waddington Gallery.

46. Letter to his parents, 24/5/42. In *Night Letters* (1980), p.56, quoting Gilbert and Sullivan, Hilton describes himself thus: 'a wandering minstrel I, a thing of rags and tatters'.

47. See M.Brown, *Gypsies and Other Bohemians: The Myth of the Artist in 19th Century France*, Ann Arbor, 1985.

48. *Lewis* (1984), p.55.

49. Ibid., p.57.

50. *Night Letters* (1980), p.178.

51. *Lewis* (1984), cat.5-7, 10-11, 79C.

52. e.g. *Night Letters* (1980), p.35; Graves (1980), cat.33,37,39,42; 1974, charcoal and gouache, 14³/₄ x 19", Jeremy Le Grice coll; 1973, charcoal and gouache, 10¹/₂ x 16³/₄", Ronnie Duncan coll; 1974, gouache, 10¹/₈ x 16³/₄", Jimmy Coxdon coll; 1974, charcoal and gouache, 14³/₄ x 18¹/₂", John Branfield coll; 1975, charcoal and gouache, 13 x 15¹/₄", Pauline Jones coll.; 1975, charcoal and gouache, 16 x 13³/₈", Bowers coll.; 1973, charcoal and gouache, 14 x 22", Christie's, 9/11/90, cat.257; 1974, gouache, 23¹/₄ x 17", Beaux Arts Gallery, Bath (1990); cat.6, Waddington's, Oct.-Nov.1974; 1973, gouache, 16 x 21¹/₂", ES1309, Waddington Gallery; charcoal and watercolour, 10⁵/₈ x 14¹/₂", B1623, Waddington Gallery.

53. For a longer version of this section of the text, see A.Lewis, 'Roger Hilton and Poetry', *Issues* magazine (Journal of the Schools of Architecture, Art and Design, University of East London), 3, 2, 1994, pp.40-55.

54. Graham's next collection *Malcolm Mooney's Land* (1970) contains a poem 'Hilton Abstract' which deals with cutting out the non-essentials and keeping close to the pulse of life, while his 1977 collection *Implements in Their Place* includes a poem reflecting on the gift of Hilton's watch after he had died.

55. Graham encouraged him when he felt 'finished' as an artist and tried to get him to stop drinking and verbally abusing others aggressively. His letters encouraged Hilton to stick with the treatment at Roehampton and to open up to a psychiatrist there. Hilton sent him paints and Graham's letters back then began to contain images. Hilton was interested in advice on writing which Graham felt unable to give. The meaning of their relationship for Graham is summed up in a letter to Hilton's widow after he died: 'very rarely in our lives we come under an influence at once profound, usually violent and always so confusing that our whole view is shaken.'

56. Graham letter to Hilton, 27/9/68.

57. Hilton mentioned his admiration for Baudelaire in 'Letter to Peter Townsend' *Studio International*, March 1974. A letter to Peter Barton dated 24/3/73 referred to his admiration for Gerard de Nerval. We know that Hilton was reading Verlaine not long before he died and especially loved his image of frightful death seated on a dragon in 'La Mort' (J.Lewinski, *Portrait of the Artist: 25 Years of British Art*, Manchester, 1987, p.87). *Night Letters* (1980) indicates requests for *the Oxford Book of Verse*, a volume of French modern verse and an Anglo-French dictionary (p.164).

58. *Lewis* (1984), p.21.

59. A counter-example working against the danger of losing the subject in favour of consciousness' response to it was provided by T.S.Eliot. Hilton clearly felt that his own art benefitted from the spare economy of Eliot's language, though Graham was dismissive of this idea. A letter from Graham to Hilton, 8/11/68, states that 'it is nonsense to say that your style (very efficient) is influenced by your many readings of Eliot's [*Four*] *Quartets*.' There is an extant tape of Hilton reading Eliot and one sheet sent to his elder brother (John Hilton estate) refers

to 'Sweeney Among the Nightingales', which Hilton no doubt would have loved for its slapstick humour counterpointing its learned references. There is of course another Eliot who preoccupied Hilton, the Eliot concerned with a sense of that moment in time when we might seem to stand outside of time. In one of the *Night Letters* (p.65), Hilton quotes lines from 'East Coker'. In the same place, he refers to his admiration for Auden.

60. P.Aries, *Centuries of Childhood* Harmondsworth, 1960.

61. This phrase is adapted from C.Macpherson, *The Political Theory of Possessive Individualism,* Oxford, 1962, p.3: 'the individual was seen neither as a moral whole, nor as part of a larger social whole, but as an owner of himself ...essentially the proprietor of his own person or capacities, owing nothing to society for them.'

62. R.Fry, 'Children's Drawings', *Burlington Magazine*, June 1917, pp.225ff, Jan. 1924, pp.35ff.

63. P.Abbs, 'Aesthetic Education: A Small Manifesto', *Journal of Aesthetic Education,* winter 1989, p.81.

64. 'We [had] some old copies of *Studio International*. There was a large reproduction of a Miro on the back of one. These magazines were in Roger's room and when I was tidying up one day, he said "Prop that magazine up there for me". I did so against a chair with the Miro facing him and it stayed there for two or three days. This was at the beginning of his gouache period.' (Rose Hilton letter to the present writer, 6/11/89, reply to questionaire 1/89). I am indebted in the following section to R.Goldwater, *Primitivism in Modern Art*, New York, 1938, chapter 6, though clearly the meaning of his whole account seems problematic now.

65. Hilton copied a passage from an unidentified French text on Klee and made a couple of Klee-influenced drawings in Album O.

66. Quoted in O.Werckmeister, 'The Issue of Childhood in the Art of Paul Klee', *Arts Mag.*, Sept.1977, p.138.

67. Graham once wrote in a letter to Hilton (9/10/68) commenting on Hilton's own description of his current images as 'simple childish things' thus: 'you can't have it both ways. As you know, they are not 'simple' or 'childish' but have in them the unexpected quick vision of a child put down through a super-sophisticated knowledge and mature selection.'

68. 'Letter to Peter Townsend' (1974).

69. J.Piaget, *The Child's Conception of the World*, St. Alban's, 1973 (1st. ed.1929), pp.188-9.

70. 'Remarks about Painting' from *Roger Hilton*, Galerie Charles Lienhard, Zurich, 1961.

71. It is difficult, of course, to distinguish his use of the look of 'child art' from the longer-standing 'primitivism' of his earlier modernism, and equally difficult to date most undated drawings. One drawing of a child (charcoal, 10 x 8", B15518, ES443, sold by Waddington Gallery to Clinton Tweedie 28/7/88) involves a conscious use of features of the earliest 'child-art' representations of the figure. A dated 1959 oil on plywood (*August 1959*, OW, 6 x 26", Waddington Galleries ES708 Y00438) mingles a child's drawing of a native American with his own painting. The centre of the panel playfully deploys the words 'War Paint'.

72. He dated Album D to 1926 and Album F to 1927. (Later drawing books Albums J,K, Q, R and X were also all dated apparently in Hilton's later hand.)

73. Interview with Jeremy Le Grice, 16/4/92.

74. T.Adorno, *Aesthetic Theory* (London, 1984), p.323.

75. These were subsequently constructed as a category of 'night letters' for the publishing market when *Roger Hilton: Night Letters and Selected Drawings* was published in 1980.

However this category needs critical handling since some of the published letters were clearly written in the day, such as those written in hospital, others are hardly letters at all, and 'autonomous' drawings were added to the 'night letters'.

76. *Night Letters* (1980), p.73.
77. Interview with Rose Hilton, 16/4/92.
78. *Night Letters* (1980), p.64: 'L'encadrement ruine les tableaux'.
79. Interview with John Miller, 18/4/92.
80. *Night Letters* (1980), p.22.
81. Ibid., p.64: 'Que j'expose ici ou là, qu'importe'; p.66, 'What one wants is an immediate place. A barn. Anywhere where one can hang the damn things'.
82. Interview with Jeremy Le Grice, 16/4/92.
83. Ibid.